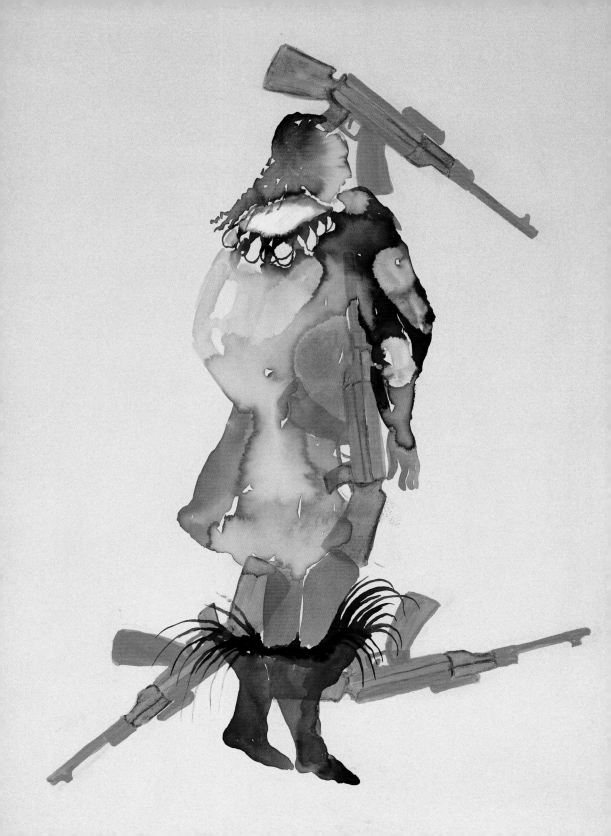

SHAHZIA SIKANDER

NEMESIS

IAN BERRY and JESSICA HOUGH

THE FRANCES YOUNG TANG TEACHING MUSEUM AND ART GALLERY

AT SKIDMORE COLLEGE

THE ALDRICH CONTEMPORARY ART MUSEUM

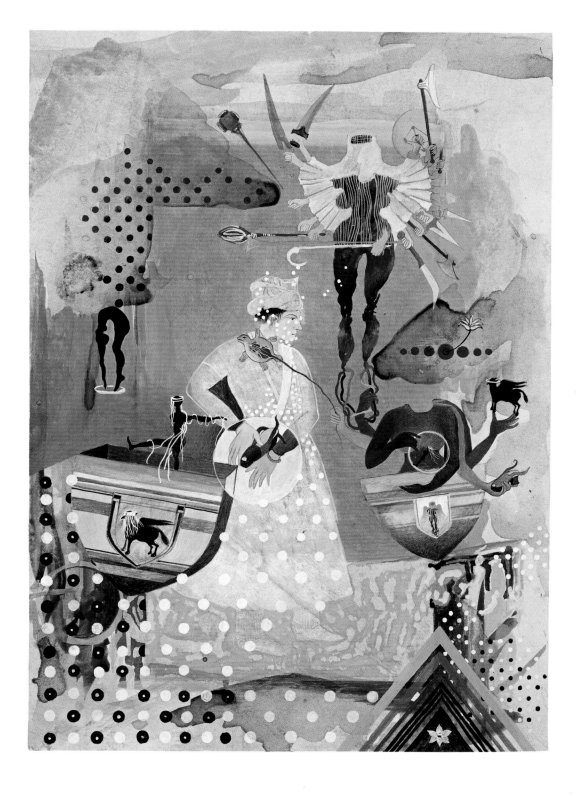

NEMESIS

A Dialogue with SHAHZIA SIKANDER by Ian Berry

The title of this catalogue, *Nemesis*, is taken from one of Shahzia Sikander's recent animated works of the same name. As the work unfolds, an elephant is built through the slow accretion of a cornucopia of smaller animals. The collaged, hybrid beast wrestles with a devil character, and is eventually destroyed in the fight. In the wake of the destruction caused by the insistent "nemesis," we are reminded that the word is also the name of the Greek goddess of divine retribution. Indian gods, like Greek gods, are often capable of enacting severe punishments on their subjects even if they are generally thought of as good. Sikander's works often highlight this dark side. And in these times of political polarity, we are often forced to think in terms of friend versus foe.

Sikander's work is inspired by a range of painting schools across both Hindu and Muslim cultures, with everything from American Pop culture and war to supermodels and fairy tales appearing in her complex paintings and animations. Her work teases the boundaries imposed by time, gender, religion, and culture.[1]

IAN BERRY: You began your interrogation of miniature painting in the late 1980s in Pakistan at the National College of Art in Lahore. What was your initial interest in working this way?

SHAHZIA SIKANDER: I elected to work in the miniature format in 1988 during my second semester of foundation year at school. The choice itself was an act of defiance. At that time, there was no interest in the miniature painting department—in fact it was viewed with suspicion. I was attracted to the inherent challenges of miniature painting. My interest was and still is to create a dialogue with a traditional form—how to use tradition while engaging in a transformative task. Over the years I have continued to try to understand miniature painting's historical significance and its contemporary relevance. I remain curious about its varied

(title page)
Plush Blush series, 2003
(one from a set of four)
Ink and gouache on paper
15 x 12"
Private Collection

(facing page)
Hoods Red Rider #2, 1997
Vegetable color, dry pigment, watercolor, and tea on wasli paper
10 1/8 x 7 1/8"
Collection of Susan and Lewis Manilow, Chicago

stylizations, and how illustrative it can be. Miniature even in its most traditional aspect is extremely multi-dimensional.

IB: Your paintings are often described as disturbing the "purity" of this traditional form.

SS: The notion of purity is interesting, because it isn't found in the practice of historical or contemporary miniature painting. It has nothing to do with purity. It has a lot to do with appropriation. Within the current practice, there is a lot of blurring in terms of what gets appropriated from older sources. What makes a work more original is always interesting, because the whole notion of copying is heavily embedded in the tradition. I was interested in practice and application both formally and conceptually. Initially the visual references for me were images found in books and exhibition catalogues printed by Western institutions. I was invested in an objective approach from the start, and I was never seduced by the romanticism of the miniature. It started by my finding ways of stepping outside the tradition in order to create a dialogue with it.

IB: Even though your work was a confrontational break with an expected form, it was received with great success in Pakistan, and it has had a lasting impact on artists there.

SS: Yes, I received a great deal of success in 1991–92 before I decided to come to the United States. I was the first to create visibility for the genre locally, as well as internationally later on. Pakistan in the 1980s was very restrictive, and in that context the National College of Arts was a haven for free thinking and expression. It was a great place to be amidst the rest of Lahore and Zia's military regime. Military presence has a way of prevailing, and either you respond in ways that are reactive or that become subversive. It is only with distance that my responses have become clear—I was barely 17 at that time. The conventional approaches in the painting department pushed me towards miniature painting

because no one else was interested in it. Its social context was so intriguing. It supposedly represented our heritage, yet we reacted to it with suspicion and ridicule. I had grown up thinking of it as kitsch. My limited exposure was primarily through work produced for tourist consumption.

I found, and still find, the presentation and documentation of miniature painting to be very problematic. In fact, by its very nature the term miniature is laden with issues of imperialism, and is usually followed by a very descriptive, almost ethnographic definition. At this time I also started to explore language in relation to the formal symbols of mathematics and logic. This is a big part of my most recent drawing series: *51 Ways of Looking*. All this started to resonate with post–structuralist theories, and I used that new information towards deconstructing the miniature.

IB: Can you talk more about deconstruction as a conceptual premise for your work?

SS: It is a given that nothing is whole. Everything has a contradiction embedded within it. Thus the notion of purity that is associated with the older painting is something to be questioned. Deconstruction involves demonstration of that issue. It is not the act of dismantling but recognition of the fact that inherently nothing is solid or pure. I read French philosopher Jacques Derrida, and was influenced by his suggestion of binary oppositions as creators of hierarchy. I saw my work in connection to notions like west/east, white/black, white/brown, modern/tradition, presence/absence, beginning/end, and conscious/unconscious. My desire to question established hierarchies, such as purity and authenticity, was informed by applying the logic of deconstruction.

IB: How did feminist theory enter your thinking at this time?

SS: I was interested in understanding feminism's different brands and roles across the globe, especially as it related to my experience in Pakistan. I was first introduced to these ideas in graduate school

from writers like Luce Irigaray, Julia Kristeva, and Helene Cixous. Equally important was reading Edward Said on one hand and Michel Foucault on the other.

The question that came to mind was always about the discourse outside the canon. What is cultural imperialism? What is essentialism? What was the representation of the other? Could representation exist outside of the binary oppositions? What could be the third space, the in-between space? I was intrigued by the concept of role reversal, especially the distance that it could afford me as an artist. Finding myself immersed in the early 1990s politics of identity, I started experimenting with the semiotic nature of various symbols that could question stereotypes of certain feminine representations, such as hairstyle, and costume as in the sari, shalwar kameez, and chador. I began to see my identity as being fluid, something in flux.

IB: Did that notion of flux gain focus when you moved to New York City? Does living in New York feel more like home to you than Lahore?

Reinventing the Dislocation,
1997
Vegetable color, dry pigment, watercolor, tea wash, and xerox on wasli paper
13 x 9 ¹/₄"
Whitney Museum of American Art, New York; Purchase, with funds from the Drawing Committee, 97.83.4

SS: Absolutely, it always has. It felt that way when I first got here. New York is essential for me. It provides me with the local and global experience simultaneously, around the clock. Its energy is infectious and productive for me. I never wanted to live in two worlds mentally, but it has been a slow process to be free of that. Only now, in the second decade of being in the United States, do I feel the separation much more deeply. There is less desire to have

approval, so to speak, from Pakistan and I am hopefully seen less as solely an "artist from Pakistan." The first serious introduction of my work was in 1997 at The Drawing Center and the Whitney *Biennial*. I was exploring experimental drawing while trying hard not to be ghettoized as a South Asian/Muslim/Pakistani/ woman artist.

However, I think what followed from 1997–2001 was exotification of some type. Most of the readings of my work focused on cultural definitions rather than the work itself. I became the spectacle in many reviews—it didn't help to have exaggerated information like making my own brushes, pigments, and paper floating around. I can clarify something here once and for all—I don't make my brushes or my pigments! I make my ideas and I try to express them in as many ways as possible. At that time I was driven by sharing as much as possible, perhaps in an attempt to shrink gaps of knowledge. But filling in the gaps doesn't necessarily change the assumptions people already are bringing to the equation.

(below left)
Eye-I-Ing Those Armorial Bearings 4, 1994–97
Vegetable color, dry pigment, watercolor, and tea on wasli paper
8 ¹/₂ x 5 ³/₄"
Private Collection

(below right)
Eye-I-Ing Those Armorial Bearings 2, 1994–97
Vegetable color, dry pigment, watercolor, and tea on wasli paper
8 ¹/₂ x 5 ³/₄"
Marieluise Hessel Collection, on permanent loan to the Center for Curatorial Studies, Bard College, Annandale-on-Hudson, New York

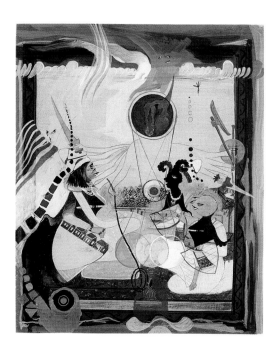

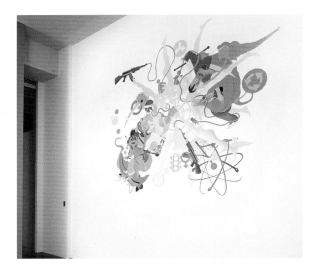

IB: Did you make any work at this time that spoke directly about identity?

SS: I made a few works that specifically addressed the notion of identity as being fluid and unfixed, primarily in response to the rigid categories I found my work and myself being placed in or put in. Identity became theatrical, malleable through conditions such as production, location, duration, conventions of staging, reception of audience, the construction of the audience as well as the substance of the performance itself, including body language, gesture etc. In one I dressed in braids and aggressive clothing and mapped my movements around an airport —observing how people react when there is a visual encounter that looks familiar and is not. In another, I wore a costume that disguised my body and thus made me transparent at times. The work got read as a plea for liberation for women who are subjected to wearing veils. I am amazed even now how limited people's understanding is. Pakistan is not Iran and Iran is not Lebanon and Lebanon is not Saudi Arabia. My being from a so-called "Muslim" country often became my primary categorization. Unfortunately it still persists.

IB: So you are pleased when viewers create distance from your story and find their own narratives in your work?

SS: Well, there is no particular narrative in my work. It definitely does not present "my story" in an autobiographical sense. My lived experiences are at times conducted as experiments to gather material that becomes fodder for work. The impulse is very different in such a context. The feedback also informs the process. I often see myself as a cultural anthropologist. I find open-ended encounters and narratives compelling and perhaps seek to express that more than anything else. Symbols, icons, and images are not

(above and facing)
Divine Circle, 2003
Acrylic on wall
Dimensions variable
Installation view,
Conversations with Traditions,
Seattle Art Museum, 2003

automatically about one thing or one way of reading. A crucial
reading for me has been the underlying exploration of beauty.
The average response to my work usually includes 'beautiful.'
For me, issues of aesthetics are always in flux with miniatures.
Its transformation from things like kitsch to beautiful, low to high,
craft to art, regional to international, artisan to artist, or group to
individual. These are interesting ideas for me. I am always exploring

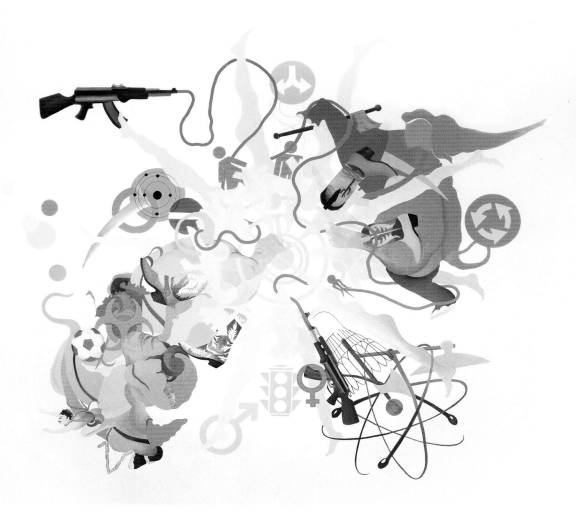

questions such as: does beauty move towards formalism? Is beauty trivial? When does it become perverse?

IB: Can you describe how your notion of flux relates to the text that has appeared in your work?

SS: The usage of text is very similar. For example, *Writing the Written* is about memory and the ability to read several languages, especially languages that come from the Arabic script. I can read them fluently, but I don't understand them. It is a very ritualistic tradition that I come from where reading the Koran was one of the many things we did, but we were reading without any understanding. This work is prompted by memories of that experience. I am interested in looking at language verses its usage and meaning—recitation of the Koran as opposed to reading it. Issues of translation and mistranslation are very important in my work. Language is as fluid and chaotic as image.

IB: This notion of fluidity is put into physical use in your studio when you layer images on top of one another, constantly moving things around. The formal properties of layering are a perfect match for all the conceptual ideas you speak about—whether you are layering washes of paint, tissue paper...

SS: ...or the layers of animation.

IB: That is your medium, layering.

SS: Yes, layering is the medium because with every addition it alters perception, every time the process provides another way to look at the same thing. Although the many layers we are addressing here are not just process related. Conceptual layering is always the focus. It becomes a means of trapping all my various issues and ideas. It also can help strip away the baggage surrounding the work.

IB: You made your first wall installation in 1997?

ss: Right, it happened in Texas when I was in residence at the Core program in Houston. It was in response to my environment. I selected one image from my vocabulary of forms and shifted the scale from 10 inches to 10 feet to mimic "big is better," but also to see what would happen to the image itself: would it become more confrontational? more noticeable? more painterly? more precise? more stylized? less exotic? more accessible? less feminine? more macho? more minimal, more economical, less precious? and so forth... I was also trying to figure out a way to navigate spatial constructs.

ib: Is it the same kind of spatial thinking when you are inside a miniature? You don't paint as many literal architectures as you did

In our mind or on our head, 1999
Acrylic and gouache on patching compound with gesso and marble dust on wall
Dimensions variable
Installation view, Hirshhorn Museum and Sculpture Garden, Smithsonian Institution, Washington, D.C., 1999

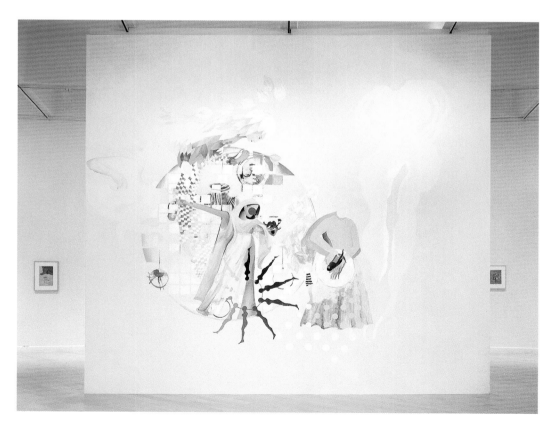

earlier, but is there any similarity between managing that artistic space and managing actual museum spaces?

SS: I think there is, because the space of the miniature painting is big in concept, even though it may be less heroic than putting paint on stretched canvas. Both spaces remain very architectural in that there remains a lot of symmetry, perspective, attention to surface, texture, light, etc.

The installations are entirely ephemeral. They are time based and created completely on site; therefore I always take into consideration the space. Such an evolving process has a parallel to miniature paintings, which are layered and change over a period of time. I always have a plan beforehand and the challenge for me is to be resilient, to make decisions which are spontaneous and risky.

The installations also provide an opportunity to be free of the miniature's spatial constraints. The picture plane is entirely about 'looking in' to a world as opposed to 'looking at' an image. The tissue installations can span up to 20 feet high and even more in length, and up to 8 feet in depth from the wall, and at no point is the work entirely visible. The imagery unfolds as one walks in and around the piece.

IB: Animation is a recent addition to your work. What does it offer that is different from drawing, painting, and installation?

SS: Digital process is yet another way for me to explore both formal and subjective issues within the tight parameters of the miniature. Combining a non-traditional medium with a traditional genre allows me to build a relationship between present and past, space and dimension, narrative and time—all in service of destabilization. In a miniature a slower more controlled pace is in operation. It is clearly a series of steps—step one leads to step two which eventually leads to step ten, allowing for the build-up of form, content, structure and materials. The process of creation hence has a hierarchy surrounding the investment of labor, which may not necessarily be true of a digital process, where there is no particular hierarchy.

Using digital technology for me is not very different from how I have worked in the past. I have always been inspired by information and images from a range of sources (whether art historical or personal) and played it out through layers in my miniatures and murals. The shift is purposefully subtle, not challenging or confrontational and technology is not instant, it is controlled. I am less interested in direct illustration, because I find open-ended, timeless narratives more compelling.

IB: *Gopi Crisis*, and several works after that including *SpiNN*, feature swarms of bodiless figures piled together like an army marching together or maybe a population which has died and vanished. How do the *gopis* function for you?

SS: *Gopis* are the lovers of the blue god Krishna in Hindu mythology. Their primary reason for existence tends to be to worship him. Using the gopi over the last several years has lead me to see it in a variety of ways—one being to use humor to address gender and power hierarchies. In this case I am focusing on the *gopi* as a formal device for abstraction. The multiplicity of the *gopis* symbolizes women's views of their own spirituality as opposed to a male-dominated view. Despite being marginalized, women have found ways to create their own spiritual space—the archetype of the Great Mother is an example of this.

If the layers are read like part of a language, strains of myths can be knit together from them and familiar fables can be conjured, albeit in incomplete or abbreviated forms. Is Blind Justice blinder with her vision intact, or are the *gopis* who lack Krishna's guidance truly lost? *SpiNN* takes imagery that forces simplified understandings of global multiculturalism to be challenged through a vocabulary that is as vague as it is specific. The notion is that a foreign image, technique, or style is creating a counter exoticism full of mutual intrusions. The title *SpiNN* also alludes to powerful mass-media corporations and to the ways in which core information about a subject is often hidden behind layers of perception that can suggest multiple meanings. Perception is shaped and

altered on a daily basis, and information is spun to show us what we want.

Fragmented Disorder, 1999
Acrylic, gouache, on patching
compound with gesso and
marble dust on wall
108 x 96"
Installation view, *Negotiating
Small Truths*, Jack S. Blanton
Museum of Art, The University
of Texas at Austin, 1999

IB: Can you describe your recent series entitled *Land-Escapes*? They seem like a break from your previous way of painting.

SS: The *Land-Escape* images are derived from details found within a few selected schools of Persian and Indian miniatures. The often-obscure elements of landscape are brought to the forefront by shifting the scale and removing all other figurative information.

The drawings are then scanned into digital files to further eliminate the hand drawn element. Although the work is inspired by a range of painting schools of both Hindu and Muslim cultures, they have been simplified and stylized to become non-nostalgic and stripped of any sentiment. They are whimsical and buoyant and are intended to transport the viewer into imaginary worlds.

IB: Would you describe these works as a single layer of information as opposed to the many physical layers found in your installations and miniatures?

SS: The layering process is in reverse in this body of work. Instead of developing layer after layer of information, I am using subtractive labor in an attempt to create a space devoid of any recollection. Whereas miniatures tend to deal with intimacy, these works are much more open in their depiction of space.

IB: Do you think the contemporary art world's focus on cultural and personal identity has lessened over the past decade?

SS: I think there was a greater focus on identity in the 1990s and it is a very different moment now. I was from another country, and people's understanding of who I was or what my work dealt with needed to be partly culturally specific. Because of this, identity issues were a natural point of discussion, but I was acutely aware that I didn't want to get stuck in any one category.

My works are a combination of overlapping commentaries on lived experiences, art history and pop culture. When art is used as a tool for transgression, it can become material for questioning— more than material for mere contemplation. Art for me is mostly experience; it is not necessarily about politics, feminism or religion. I think that boundaries do exist, be they physical, emotional, geographical, cultural or psychological. My role as an artist is not about being political, but to point at the shifting nature of such boundaries.

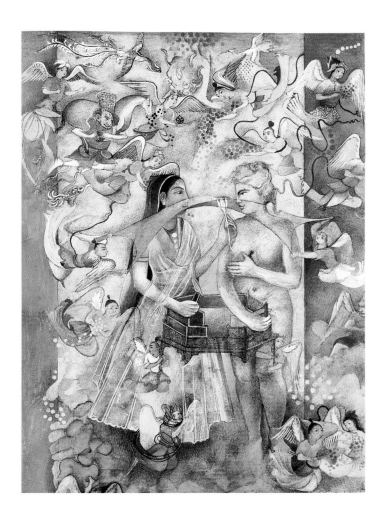

IB: How would you describe the war images that appear in some of your recent work? Are they a reflection of what we are living through now?

Sly Offering, 2001
Vegetable color, dry pigment, watercolor, ink, and tea on wasli paper
8 ¹/₈ x 5"
Collection of Judy and Rob Mann, Providence, Rhode Island

SS: I think they are a reflection of what is happening around the world. My work has always been in response to my lived experience, providing me with a space of concern, or a space of expression. I search for loaded images. I am interested in the duality of things and I find that when I move back and forth between New York and Lahore, the perspective shifts.

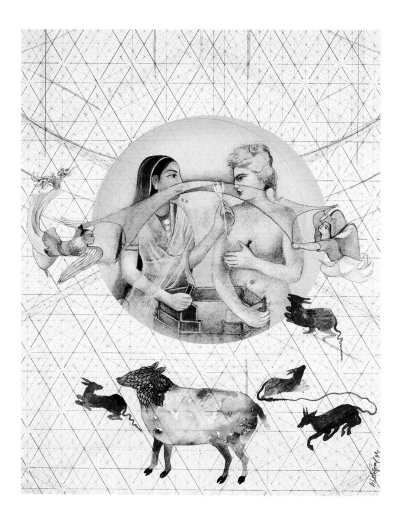

When you have the liberty of distance from a situation, you become more objective and perhaps can engage in a more meaningful dialogue. I try to engage with very specific issues that may resonate with others, and thus exist in our larger social consciousness, without suggesting answers. I am never interested in providing a conclusion.

Offering 1, 2003
Gouache and digital imaging
on paper
12 3/4 x 9 3/4"
Private Collection

1. Elements of this introduction are based on the introductory text to the exhibition authored by Ian Berry and Jessica Hough

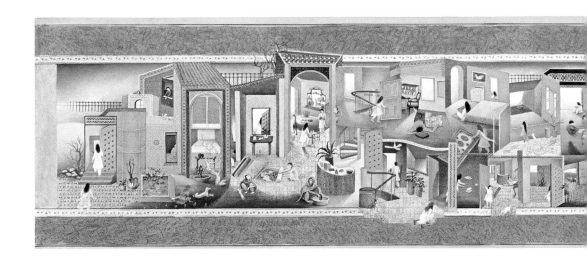

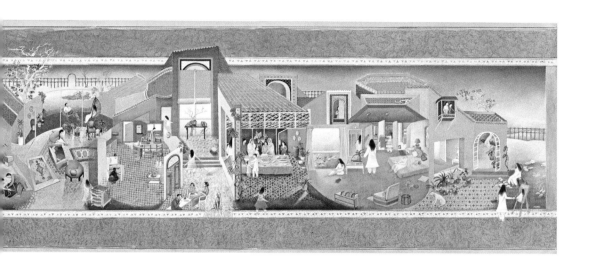

The Scroll, 1991–92
Vegetable color, dry pigment,
watercolor, and tea on wasli paper
13 ¹/8 x 63 ⁷/8"
Collection of the artist

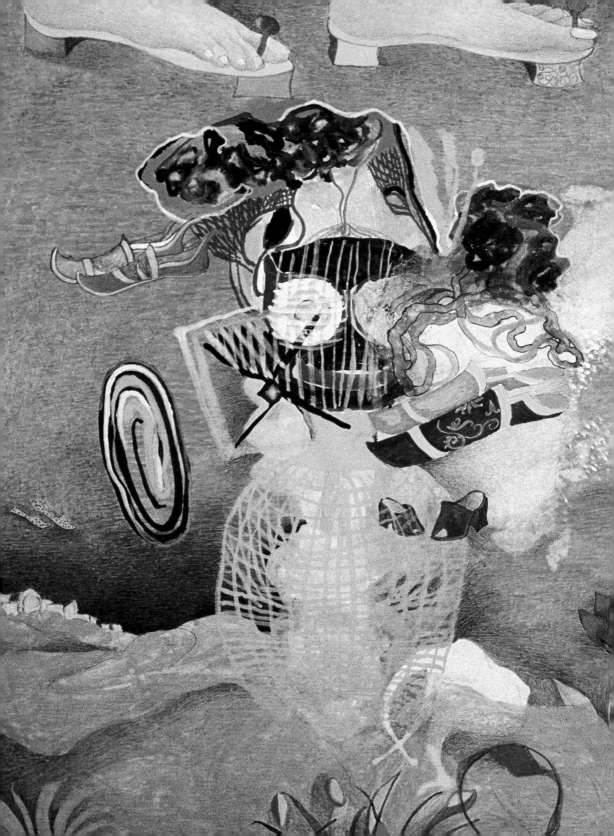

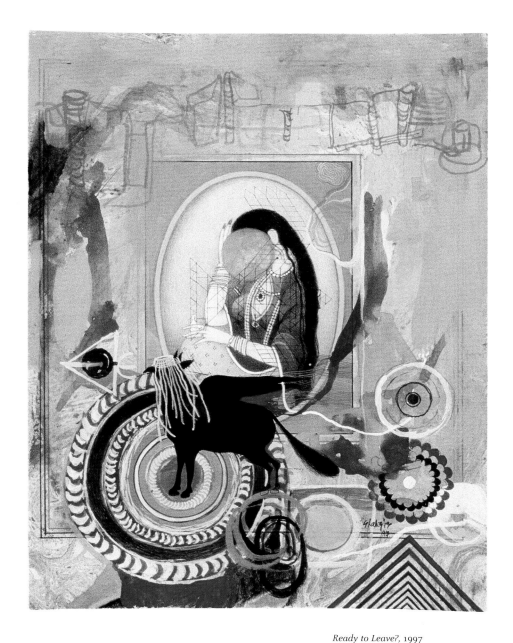

(facing page)
Uprooted, 1995 (detail)
Vegetable color, dry pigment, watercolor,
and tea on wasli paper
8 ¹/₂ x 7 ¹/₄"
Collection of Aliya Hasan, Denver, Colorado

Ready to Leave?, 1997
Vegetable color, dry pigment, watercolor, ink,
and tea on wasli paper
9 ⁷/₈ x 7 ⁹/₁₆"
Whitney Museum of American Art, New York;
Purchase, with funds from the Drawing
Committee, 97.83.3

Spaces In Between, 1996
Vegetable color, dry pigment,
watercolor, and tea on wasli paper
11 x 10"
Private Collection, Houston, Texas

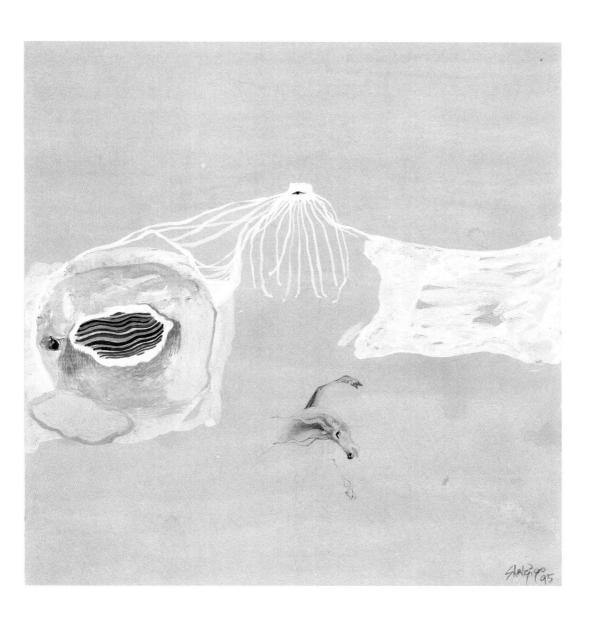

Fleshy Weapons, 1997
Acrylic, dry pigment, watercolor,
and tea on linen
96 x 70"
Private Collection

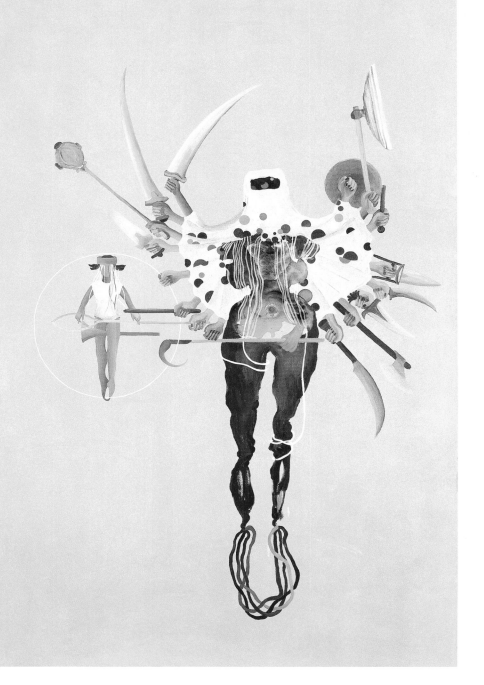

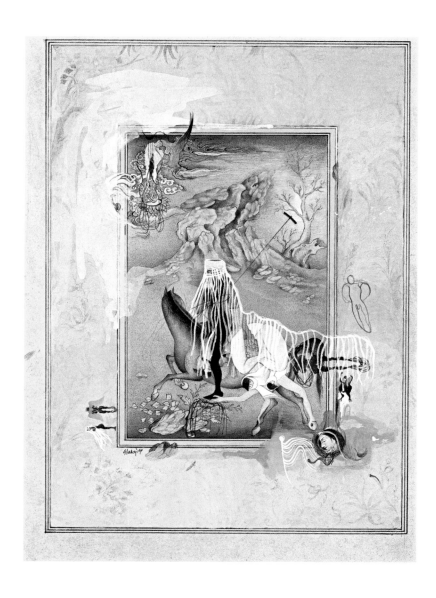

Who's Veiled Anyway?, 1997
Vegetable color, dry pigment, watercolor, and tea
on wasli paper
11 ¹/₄ x 8 ¹/₈"
Whitney Museum of American Art, New York; Purchase,
with funds from the Drawing Committee 97.83.1

Facing page:
Beyond Surfaces, 1997
Ink and gouache on tissue paper
on wall
Dimensions variable
Installation view, Deitch Projects,
New York

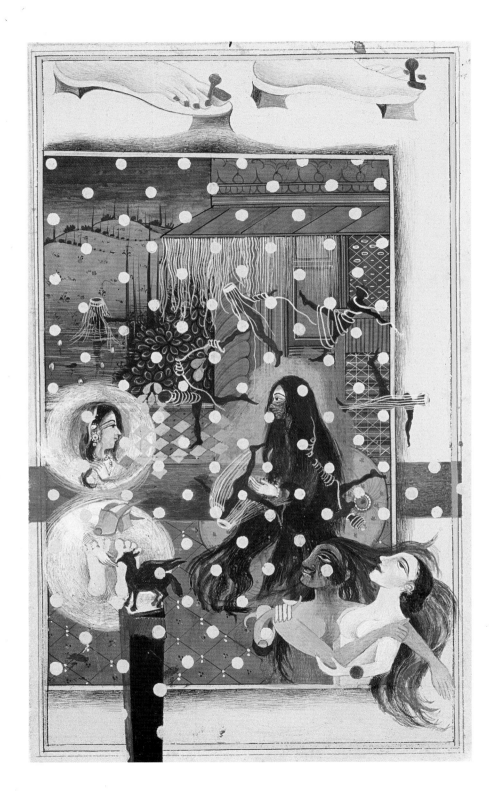

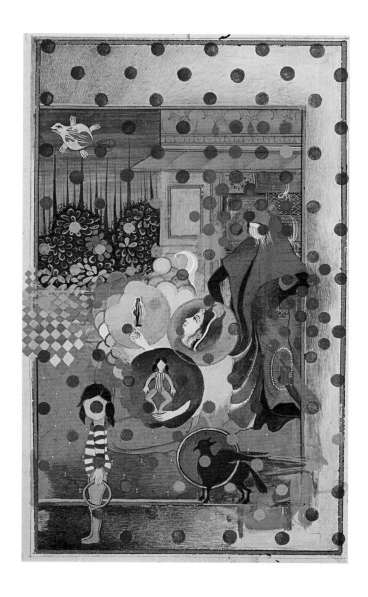

(facing page)
Then and N.O.W—Rapunzel Dialogues
Cinderella, 1997
Vegetable color, dry pigment, watercolor,
and tea on wasli paper
7 $^1/_{16}$ x 4 $^1/_4$"
Collection of Dakis Joannou, Athens, Greece

Red Riding Hood, 1997
Vegetable color, dry pigment, watercolor,
and tea on wasli paper
7 x 4 $^1/_8$"
Collection of Dakis Joannou, Athens, Greece

Monsters Within, 2001
Vegetable color, dry pigment, watercolor, and
tea on wasli paper
14 1/2 x 11"
Virginia Museum of Fine Arts, The Adolph D.
and Wilkins C. Williams Fund

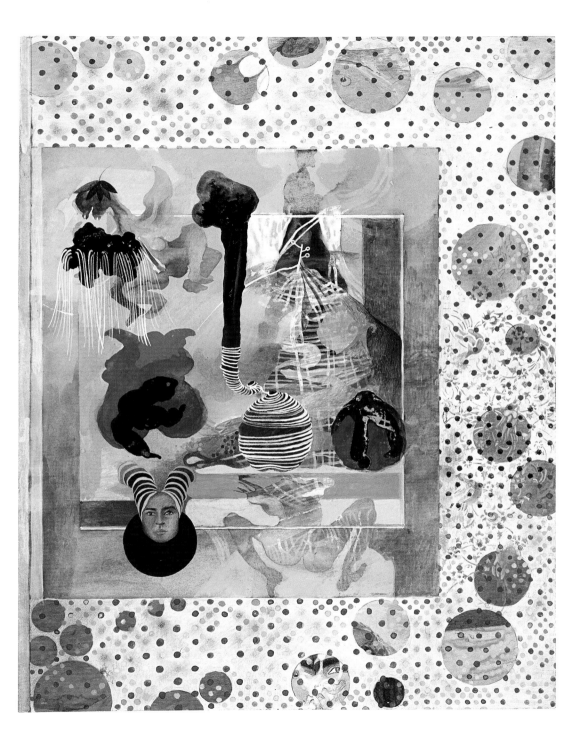

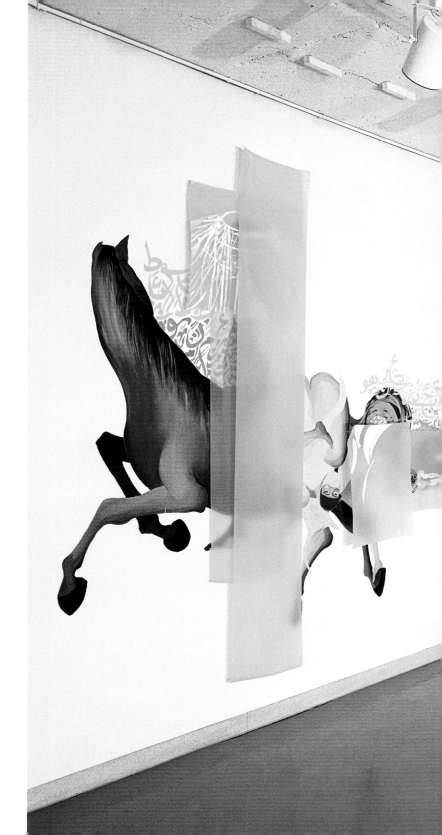

Untitled, 1998 (detail)
Acrylic, gouache, ink and
tissue paper on wall
12 x 45' overall
Installation view, *On the
Wall*, Contemporary Art
Museum, St. Louis, 1998

34

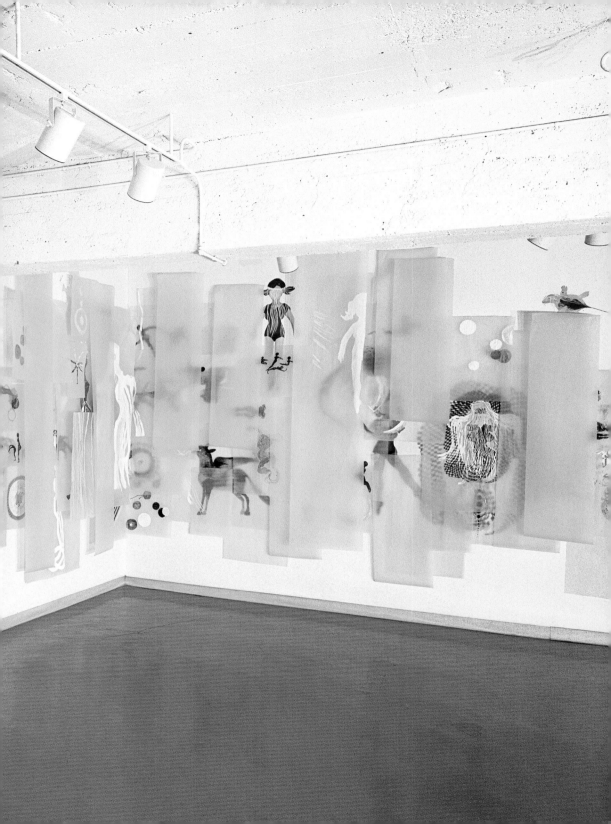

(facing page)
Writing the Written, 2000
Vegetable color, dry pigment, watercolor,
and tea on wasli paper
8 x 5 5/8"
Private Collection

Riding the Written, 1993
Screen print, vegetable color, dry pig-
ment, watercolor, and tea on wasli paper
12 x 9"
Collection of Bradford City Museum,
Bradford, United Kingdom

(facing page)
Riding the Ridden, 2000
Vegetable color, dry pigment, watercolor,
and tea on wasli paper
8 x 5 ³/₈"
Collection of Niva Grill Angel, New York

Writing the Ridden, 1993
Screen print, vegetable color, dry pigment,
watercolor, and tea on wasli paper
12 x 9"
Collection of Bradford City Museum,
Bradford, United Kingdom

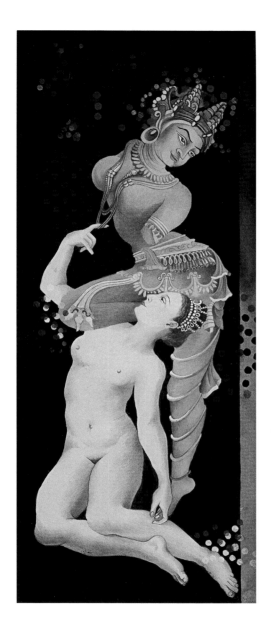

(above left)
Maligned Monsters, 2002
Watercolor, dry pigment, and tea
on wasli paper
12 $^1/_2$ x 5"
Collection of the artist

(above right)
*Projects 70: Janine Antoni, Shahzia
Sikander, and Kara Walker*, 2000
Installation view, Museum of
Modern Art, New York, 2000

(facing page)
Maligned Monsters II, 2002
Graphite on paper
16 $^1/_2$ x 13 $^1/_2$"
Collection of Elaine Berger, New York

Pleasure Pillars, 2001 (detail)
Vegetable color, dry pigment,
watercolor, ink, and tea on
wasli paper
12 x 10"
Collection of Amitta and
Purnendu Chatterjee, New York

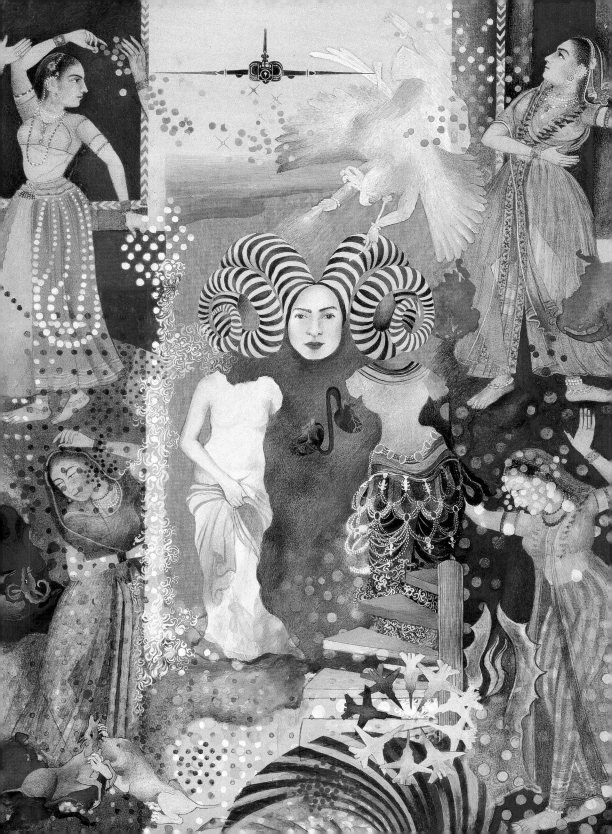

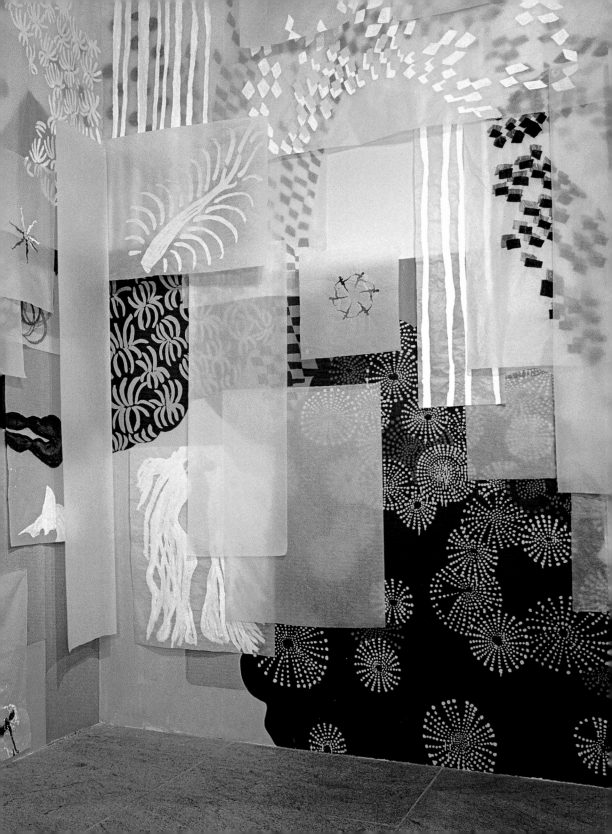

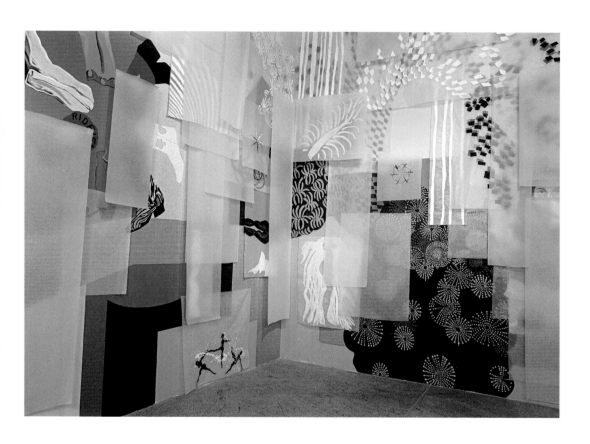

(above, detail on left)
Chaman (1), 2000
Acrylic, gouache, ink, and tissue paper on wall
Dimensions variable
Installation view, *Acts of Balance*, Whitney Museum
of American Art at Philip Morris, New York, 2000

(overleaf)
Chaman (3), 2001
Acrylic, gouache, ink, and tissue paper on wall
Dimensions variable
Installation view, *Threads of Vision*, Cleveland
Center for Contemporary Art, Cleveland,
Ohio, 2001

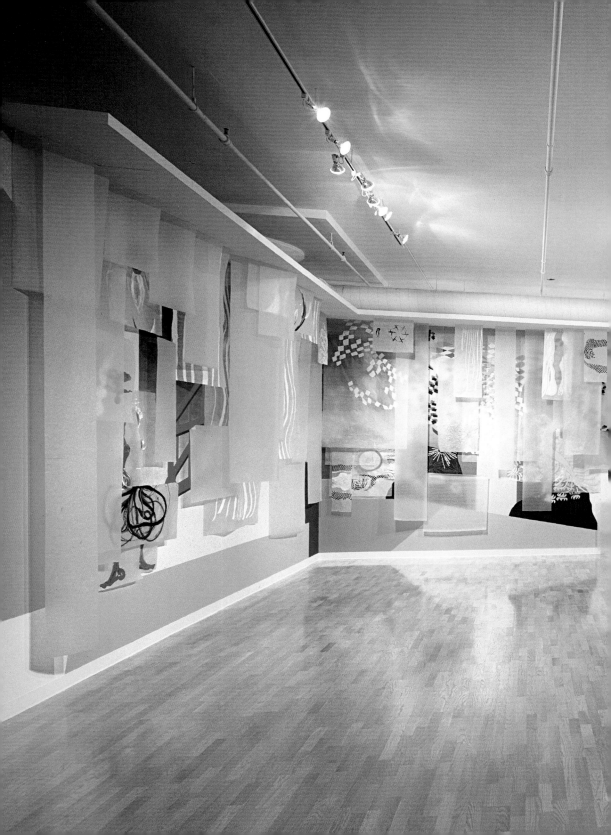

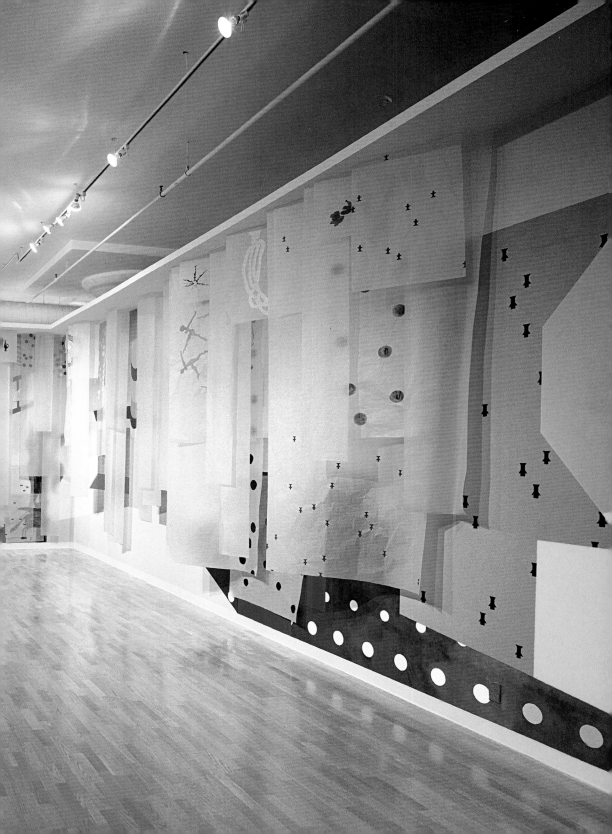

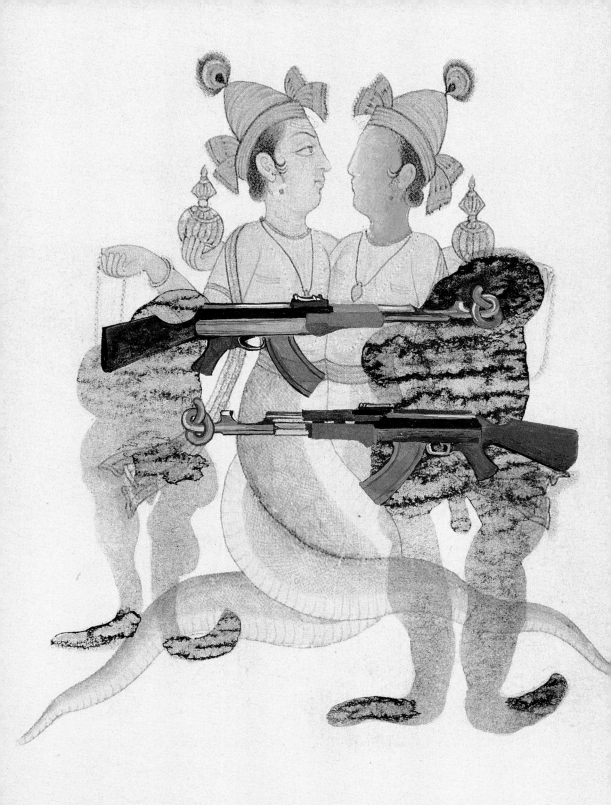

Entanglement, 2001
Vegetable color, dry pigment, watercolor, ink, tea,
and photogravure on wasli paper
8 x 5 $^1/_2$"
Collection of Annika Rahman and Ronald Creamer

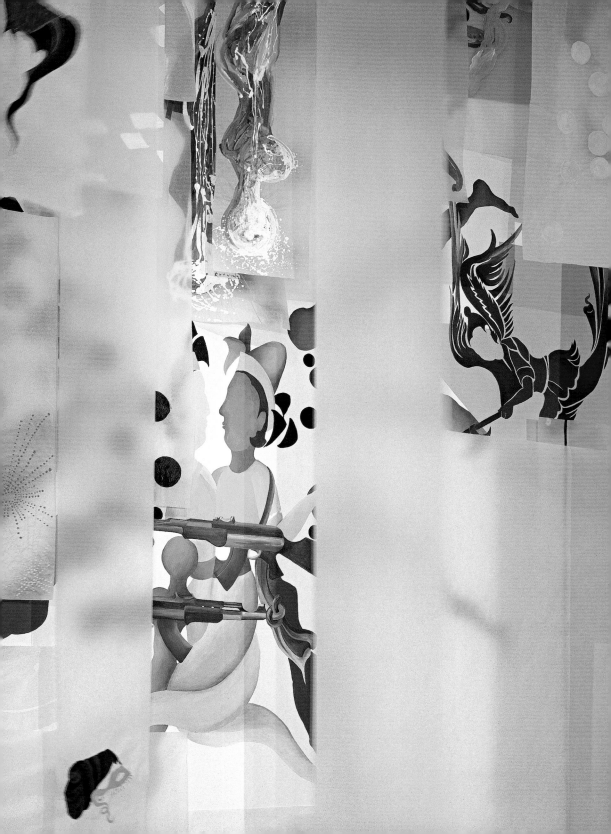

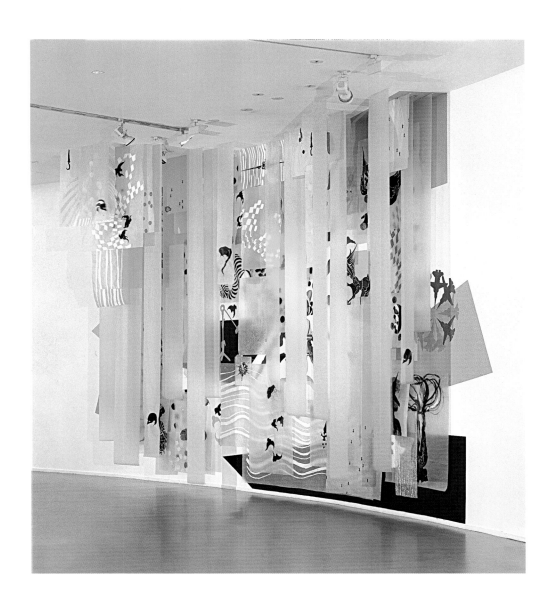

(above, detail on left)
Spin, 2002
Acrylic, gouache, ink, and tissue paper on wall
Dimensions variable
Installation View, *Urgent Painting*, Musee d'Art Moderne
de la Ville de Paris/ARC, Paris, 2002

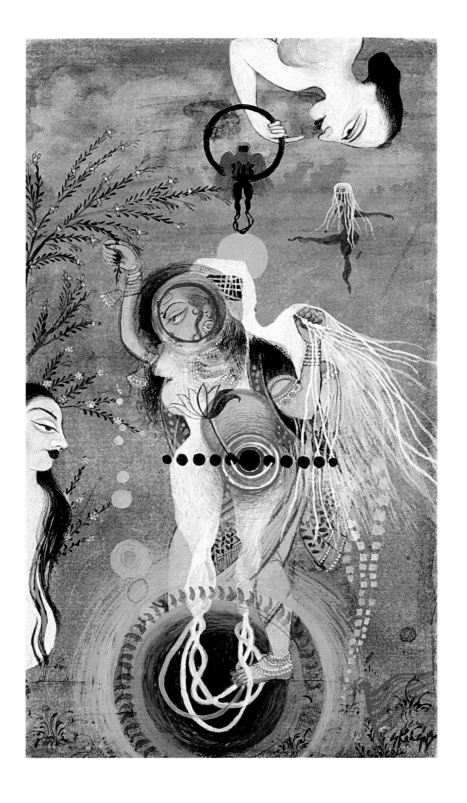

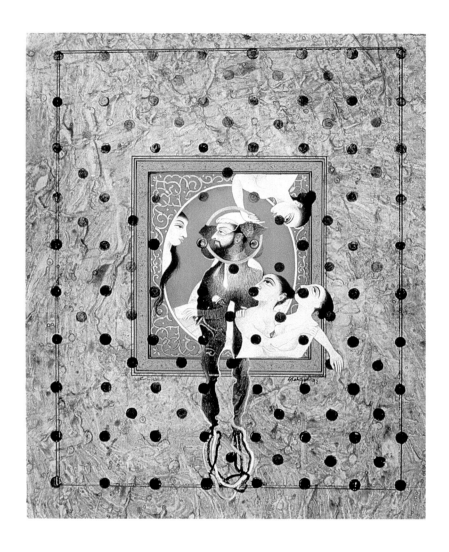

(facing page)
Uprooted Order, Series 3, #1, 1995
Vegetable color, dry pigment, watercolor,
and tea on wasli paper
6 5/8 x 3 5/8"
Museum of Fine Arts, Houston, gift of
Joseph Havel and Lisa Ludwig, 2003.728

Perilous Order, 1997
Vegetable color, dry pigment, watercolor,
and tea on wasli paper
10 3/8 x 8 3/16"
Whitney Museum of American Art,
New York; Purchase, with funds from
the Drawing Committee, 97.83.2

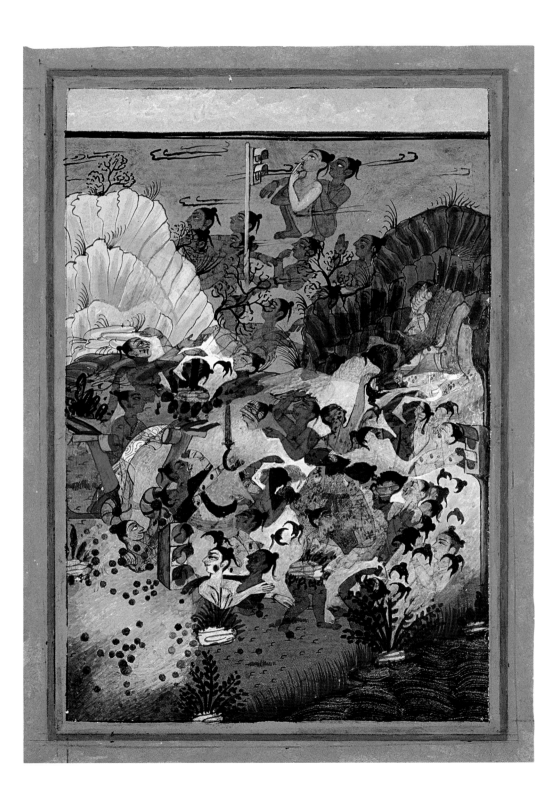

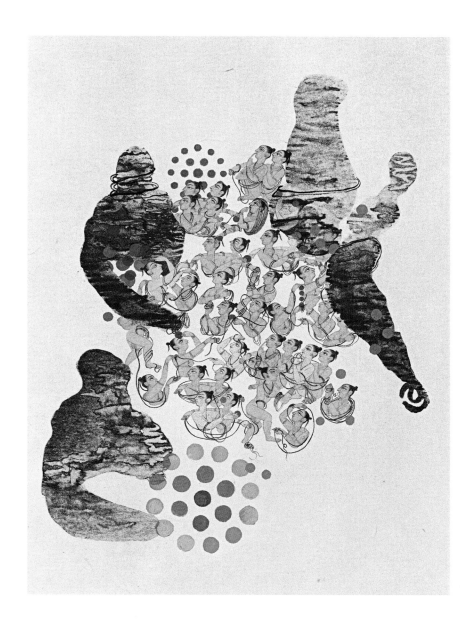

(facing page)
Turmoil, 2001
Vegetable color, dry pigment, watercolor,
and tea on wasli paper
7 x 5"
Collection of Phillip Isles, New York

Gopi Crisis, 2001
Vegetable color, dry pigment, watercolor, ink, tea,
and photogravure on wasli paper
9 ¹/₂ x 6"
Courtesy of the artist and Brent Sikkema, New York

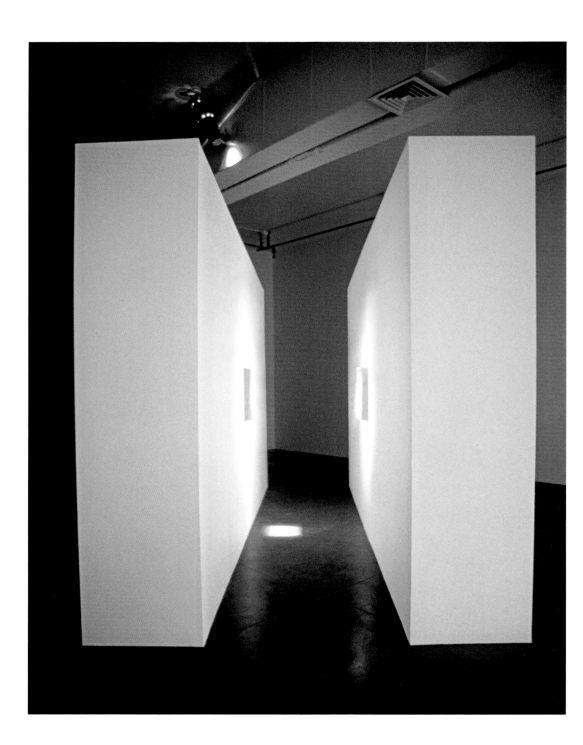

ILLUMINATIONS

by Jessica Hough

In Sikander's 2003 video installation *SpiNN*, a painting on paper hangs face to face with a digital relative. The framed painting and the framed monitor, showing a computer-generated animation, are hung on freestanding walls, which face each other to create a narrow corridor. A viewer who enters this corridor stands between the still and moving images. *SpiNN* provides an apt introduction to the artist's venture into digital animation and positions us literally where her interest lies—in exploring what movement, sound, and time can offer her heretofore still images. The animation in the video, like others the artist has produced, is in many ways merely an extension of her drawing and painting, allowing her to capture and reveal to the audience her vision in a time-based format.

Longtime admirers of Sikander's work will likely have come to appreciate how her paintings, drawings, and installations reveal themselves over time. With repeated viewing comes an opportunity to sort through the layers of imagery and meaning. Sikander's animations—*SpiNN*, *Nemesis*, and *Pursuit Curve*—offer an opportunity to begin to understand on a more profound level the artist's creative mind. The sequencing within her videos not only builds a narrative but also builds relationships between objects and concepts that allow us a glimpse at the artist's thinking. Metaphorical, symbolic, narrative, and formal play, which is at the core of Sikander's work, is revealed more immediately. Each of the works, to different degrees, was produced by drawing an image and then translating it into a digital file through a scan. Sikander would then add to the drawing and scan it again. By repeating this over and over, she built up a series of stills that could be linked together to make an animation. She then was free to add effects and actions using computer software.

Animating her drawings has allowed the artist to not only reveal her process, as we essentially witness a "painting" being made, altered, and even in some cases obliterated, but also to

(facing page)
Intimacy, 2001
Digital animation and painting,
watercolor, dry pigment, vegetable
color, and tea on wasli paper
Painting: 8.5 x 11", installation
dimensions variable
Installation view, Art Pace,
San Antonio, Texas
Collection of Michael and Jeanne
Klein and the Jack S. Blanton
Museum of Art, The University
of Texas at Austin

expand the narrative and dramatic qualities of her work. In each of her digital works an open-ended story is conveyed. There are good guys and bad guys, suspense and resolution—all of the things you would want to see in a film. The movement and time allow the artist to bring out the narrative that is buried in a static painting, where the artist uses the device of layering to reveal complexity. Here, on some level, the layers are undone to reveal the story within the painting.

The animated component of *SpiNN* [pp. 62–63] depicts an open-ended drama, which primarily takes place inside the kind of durbar hall where Mughal[1] emperors and their courtiers might have held audiences. The durbar hall appears flat, like a painted stage set, as it might have historically appeared in an Indo-Persian painting. The ceremonial hall, which would have provided an imposing backdrop to reinforce the emperor's position of power, here provides a stage for a different activity. Small groupings of *gopis*, the female cowherders and devotees of Krishna in Hindu mythology, begin to gather. Not only are these *gopis* art-historically out of place in a royal court, there are also more of them than would typically be found in a miniature painting.[2] They appear to be multiplying ominously and gathering in a great group. But Krishna, their usual focus of attention, is nowhere to be found. Are they organizing? Unionizing?

As the hall becomes filled with women, the stylized hairdos of the *gopis* become separated from the figures and the bodies fade away. Were they *gopis* at all, or perhaps only disguised as these devoted followers? The black hairdos take on the character of birds or bats, swarming into a threatening yet orderly flock. The flock spins in a circle as it becomes dense and beneath it emerges the black silhouette of a winged warrior, apparently having been generated by the swarm. This action, however, stays within two-dimensional space—swarming not out toward us, but rotating mechanically on an axis counter-clockwise.

Still from *Intimacy*, 2001
Computer animation
4 minutes
Collection of Michael and Jeanne Klein and the Jack S. Blanton Museum of Art, The University of Texas at Austin

Animation has provided a way for the artist to reveal the complexity of the iconography she invents, so that symbols flip-flop—seeming to be one thing and then suddenly something else entirely. While this is also present in her works on paper, viewers often get locked into a single reading. Here the artist has more control to move the associations one way and then another from one moment to the next. The sudden transformation of the *gopi* hairdos into birds is one example of how with the help of time and movement, Sikander can push and pull imagery so that the viewer sees it more than one way. Sikander engages both narrative and purely formal aspects simultaneously. Here, while the hairdos can be read as symbols, the swarm is also a formal element, which serves to obliterate the image beneath it, as a whirlpool might. Sikander has always worked in this manner, trying to balance both formal and narrative qualities in her work, but the animations have made this dichotomy more obvious.

The *gopis* are interesting characters for Sikander to explore in her work. They are essentially nameless figures whose identity is defined in relation to Krishna. In one story, which is sometimes depicted in paintings, Krishna steals the clothes of the *gopis* while they are bathing. He convinces them to come to him one at a time and confront him in their nakedness. According to the story, the women were not too upset with him about this. The *gopis* in *SpiNN* are also depicted nude. But perhaps in Sikander's updated version of the story we see how the *gopis* might have organized and responded to the incident differently. In the painting that hangs across from the framed monitor, Sikander has depicted justice personified, sitting among the *gopi* women.

As the hairdos-cum-birds gather, we may be reminded of the famous Hitchcock film, *The Birds*, in which birds gather, organize, and attack the residents of a California fishing village. As has been a theme in Sikander's work in general, benign figures and creatures reveal their more threatening and mysterious side. Here the *gopis*, much like Hitchcock's birds, reveal

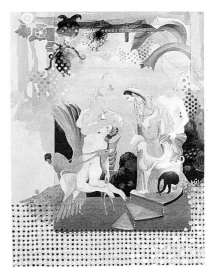

Intimacy, 2001
Dry pigment, watercolor, and tea on wasli paper
8 ¹/₂ x 11"
Collection of Michael and Jeanne Klein and the Jack S. Blanton Museum of Art, The University of Texas at Austin

Painting from *SpiNN 2*, 2003
Vegetable color, dry pigment, watercolor,
and tea on wasli paper
8 x 11"
Collection of Ann and Ron Pizzuti

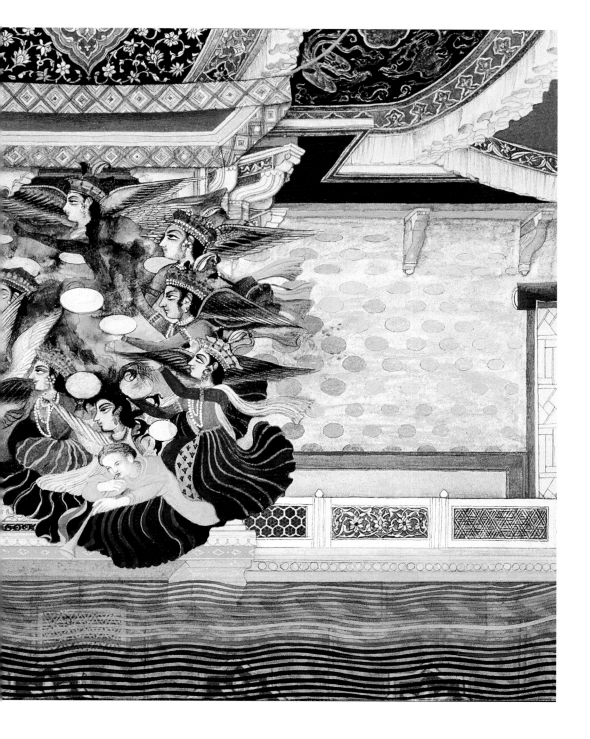

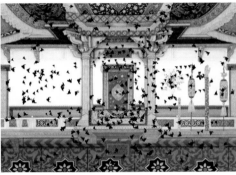

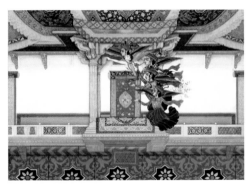

Stills from *SpiNN 1*, 2003
Digital animation with sound
6:38 minutes
Collection of Rachel and Jean-Pierre Lehmann

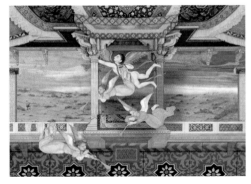

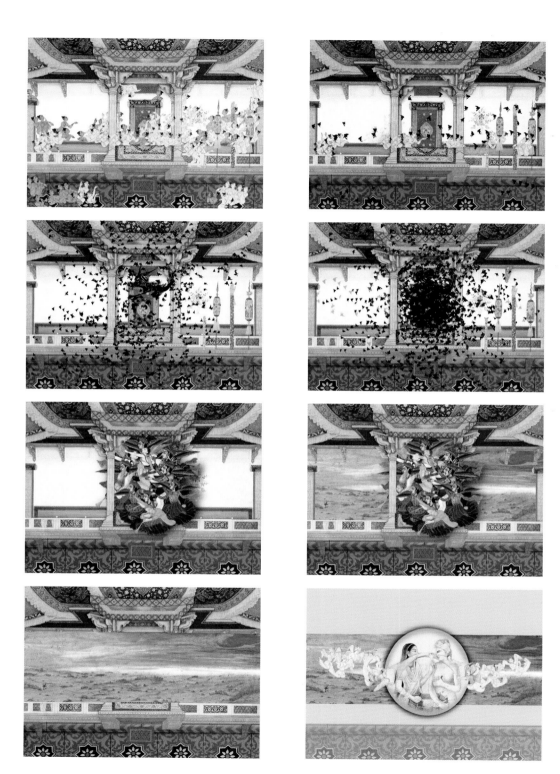

themselves to be powerful, organized, and unpredictable. We don't know what they are up to but their actions warn us to keep our distance. However, unlike Hitchcock's avian antagonists, Sikander's dark forces never lash out in full, never quite reveal the true extent of their destructive potentials. So that although we do get a potently anxious sense of something disturbingly amiss, we must carry home the weight of that unresolved tension.

Our experience watching Sikander's animations is made more cinematic and engaging through the use of music. The soundtrack for *SpiNN*, produced by David Abir, includes Western master works such as Mahler's *Fifth* in the opening scene and Igor Stravinsky's *Rite of Spring*. Abir recomposed these works using Iranian instruments. This hybrid accompaniment to Sikander's images heightens the drama already unfolding before us.

The music, which rises to a climax with the swarming flock, finally indicates relief and resolution somewhat comically, by a change in music and the appearance of angels. The first angel slides in rigidly from right of screen, as if on a string. And the others fade in one by one. Angels, which are not foreign to Indo-Persian painting (visitors to the courts brought gifts of art and books from around the world, including Christian-themed paintings), seem like props with their scarves mechanically flapping in an impossible breeze that blows in two directions. Regardless, their arrival is accompanied by a temporary peace in the scene. But at the close of the narrative sequence, we are transported outdoors again, where the sight of demons (fallen angels?) and a change in music indicate to us that evil still lurks.

The title *SpiNN* refers on one hand to the hairdos of the *gopis*, which literally spin in circular formation. But as in all of Sikander's works, nothing ever has a single reference point or meaning. The unusual capitalization in the title might remind us of the ubiquitous CNN, seen by some as a "spinner" in its own right, whose singular perspective on world events is immensely influential or, some might argue, detrimental. More broadly, *SpiNN* affords the artist an opportunity to define the "spin" on history—to re-tell a story using a different interpretation, or unlike CNN, multiple interpretations. Perhaps seeing Krishna's *gopis* apart from him allows

us to imagine for the first time their strength in numbers. While devoted, they do not lack ambition of their own. And perhaps, like many of the characters Sikander depicts, they are not what they at first appear to be—they are changeable and adaptable.

Nemesis (2003) [pp. 72–73] is a work that Sikander has shown both on a small flat screen and projected large in a darkened room. In it, the artist depicts an elephant being built, piece by piece starting from the rear of the body, out of ferocious and gentle animals alike, much like one that might be found in a Mughal manuscript painting. Each animal clings by claw or mouth to the animal in front of it including a human figure at the center. The composite style of painting from which *Nemesis* borrows was popular in the sixteenth to eighteenth centuries in Iranian and Mughal Indian manuscripts, and is generally thought to be one that flaunts an artist's skill.[3] Here Sikander shows off her own ability to construct a beast from delicately rendered animals. In this respect, she aligns herself with artists of the past.

However, Sikander's composite creature is far from simply an exercise of skill. Hers is alive and may well contain the strengths of all of the animals and its human rider combined. When a demon appears on its back, the elephant rears and throws the unwelcome rider to the ground. The fight destroys the creature, which we witness severing at its weak links, breaking apart and disappearing. Like the gopis in *SpiNN*, Sikander empowers the composite elephant in her animation. While neither *SpiNN* nor *Nemesis* is political in an explicit way, we get the feeling that Sikander is in the habit of empowering the powerless, even if only symbolically. The term nemesis not only describes an unconquerable foe, it is also the name of the ancient Greek goddess of divine retribution.

Pursuit Curve (2004) [pp. 82–83], Sikander's most recent animation, was also composed using digital files of scanned paintings but a larger portion of it was realized using devices available through computer software. In this work, Sikander exploited more of what the computer-as-tool could offer her—color fades, repeated actions, objects multiplying. As a result, the animation has a more fluid feel and is further removed from the process of painting.

In *Pursuit Curve* the viewer indulges in a lush landscape of

imagery both figurative and abstract. The animation is presented as a projection in a fully-darkened room, an experience closer to actually sitting in a theater. Film and video curator Chrissie Isles refers to such environments as "the dark, reverie-laden space of the cinema,"[4] and reverie is in part what we experience when watching *Pursuit Curve*.

The journey is different from those depicted in Sikander's earlier works. While day turns to night twice over in the narrative, Sikander has us looking closely at some elements in the landscape, and distantly at others. In *Nemesis* and *SpiNN*, the vantage point is from a fixed perspective, while the new work makes us feel as though we have traveled across, and into the landscape. We might be reminded of Charles and Ray Eames's 1977 film *Powers of Ten*, during which we are led on a journey which starts with a man lying on a picnic blanket in a park, zooming out by powers of ten into the universe, and then returning to the man to explore the microscopic world inside his hand.[5] Similarly, Sikander sometimes has us wondering whether it is the microscope or the telescope through which we gaze.

The title *Powers of Ten* is a mathematical reference, and so too is *Pursuit Curve*, a term used to describe the path an object takes when chasing another object. In Sikander's video, one image transforms into the next, which melds into the next, in a journey intended not to lead to a specific place, but rather to offer the viewer an opportunity to follow in the path of the artist's creative trajectory.

Interestingly, while working on *Pursuit Curve*, Sikander completed a suite of drawings titled *51 Ways of Looking*, which when considered alongside the animation helps us understand the breadth of Sikander's interests, and the relationships she draws between disparate themes. The drawings could almost be cells in an animation. They are all the same size and they hang tightly in sequence so that the viewer can't help but make connections between one drawing and the next. The suite begins with a solid black rectangle, as a film might begin with a black screen. In the next drawing (or "frame," as we might like to think of it) a floral border is added, and then in the next drawing the border invades

or appears to eat away at the solid black mass. Not all of the drawings are so tightly related; in fact the hanging order was only loosely conceived beforehand, with the final decision being made on-site during the installation. But what is obvious is the way in which one drawing appears to provide the seed for the next. In other words, certain formal characteristics or themes in one might be the genesis for a second, and so on.

The progression in the animation works in much the same way with seemingly unrelated images leading into each other. While *Pursuit Curve* is more distanced from painting, there are moments in the video when we are reminded of the two-dimensional surface and even the quality of paper that provides the support for Sikander's paintings. In the opening scene, the artist initially fools us into thinking we are looking at a fully dimensional space. During that scene a collection of objects hover and buzz in the form of a sphere. Slowly the form begins to break apart as the objects dart here and there erratically. In this instance the forms seem to come out toward us, and the black space over which they hover is apparently infinite. But the shapes themselves, which we finally understand are turbans when we see them in stillness in the next scene, are flat, like cut-outs. In this way the artist brings us back to the two-dimensional plane of the painting. We are reminded of painting once more in a scene during which starburst shapes bloom in an open sky. Each emerging shape starts as a pinpoint of color and then spreads, resembling the moment a paint-laden brush touches wet paper.

When a few of the turbans finally come to stillness and attach themselves to the heads of a group of men in the next scene, we are reminded of *SpiNN*. In that earlier work the opposite transpires—the *gopi* hairdos detach themselves from the bodies of the women. We begin to understand now, that for Sikander the turban and *gopi* hair are stand-ins, on some level, for men and women. But the simplicity of the abbreviated forms allows the artist to use them freely and to twist and change their reading in her work. The bodies of the men soon fade and leave an outline that resembles a craggy rock formation, suggesting a link between their lives and the earth. We then are delivered into a display of

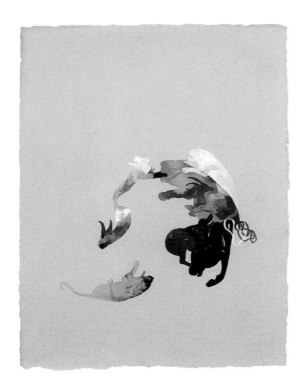

blooming starburst shapes which could be read as celebratory fireworks or exploding bombs, benign scientific growth patterns or bleeding wounds. Sikander always leaves the viewer to come to their own understanding of the work.

Much of the imagery in *Pursuit Curve* is inspired by landscape and its connection to human history. The repeated quivering turbans in the opening scene at once suggest bees buzzing around a hive, cells under a microscope, or the break-up of a celestial body. No matter what association might be made, the viewer gets the impression that he or she has witnessed a genesis—living or celestial. In the last scene, the turbans appear again, this time stacking one by one into a pile like bodies after a battle. The pile seems to sit beneath a hill where stylized trees are rooted. Veins or roots appear beneath the hill, possibly suggesting the cycle of life, death, and regeneration—an apt place to close the narrative after the video's opening scene of buzzing life.

While Sikander is absorbed by the history of miniature painting, her work is only in small part about looking back. She brings forth this source material, empowers it to speak to us about the present, and encourages us to, if not re-imagine the past, at least see this area of art history with fresh eyes. Sikander's recent foray into digital animation is a brave, ambitious, and perhaps irreverent move. She more or less abandons those aspects of her studio practice that she knows so well—pigment, texture, paint handling, the particular qualities of different papers—in order to pursue the conceptual aspects of the miniature. As viewers, we are now directed away from the luscious and tactile components of Sikander's work that tend to trap us in the literal (and the traditional). We are instead re-oriented, as the artist would wish, to think about

Candied, 2003
(one from a set of 20)
Ink and gouache on paper
15 x 11"
Private Collection

her work (and perhaps even the work of hundreds of Indo-Persian painters from the past) conceptually.

The artist is suggesting that for the moment we forget the handmade paper, forget the rich pigments, forget the tempting surfaces, and look at how inventive and conceptual this realm of the miniature can be. Even more than that, by departing from the medium of the miniature in these works, Sikander frees herself from some of the historical parameters that in certain instances have constrained the dialogue around her work. The very same history that inspires Sikander also has tethered her. Moving to a digital format provides an opportunity for the artist to see her work contextualized differently.

The history of art making is all about the push and pull between tradition and innovation. Even as she keeps one foot steadily grounded in art history, Sikander is in the habit of tugging that history and taunting it to reveal more to us. The use of video allows us to access both history and the artist's own imagery in a different way. Through Sikander's animations, miniature paintings speak out loud. They act out and misbehave, belying their historical parameters and polite scale. For Sikander, this tradition is an endless source of inspiration. Her exploration and engagement with these works honors the tradition and impacts the way in which we see the history of miniature painting and the world it depicts.

Thanks go to Deborah Hutton, Carolina Pedraza, Anni Shamim, and Shahzia Sikander for their help with this text.

1. Muslim dynasty in India in the sixteenth to nineteenth century.
2. Deborah Hutton, visiting professor, Skidmore College, e-mail correspondence, April 8, 2004.
3. Marianna Shreve Simpson, "Arab and Persian Painting in the Fogg Art Museum," *Fogg Art Museum Handbook, Vol. II* (Fogg Art Museum, Harvard, Cambridge, Massachusetts, 1980), p. 80.
4. Chrissie Isles, "Between the Still and Moving Image" in *Into the Light: The Projected Image in American Art 1964–1977,* (Whitney Museum of American Art, New York, 2001), p.33.
5. The connection between Sikander's work and the Eames's *Powers of Ten* was suggested to me by architect Gulzar Haider, who visited the exhibition at The Aldrich in fall 2004.

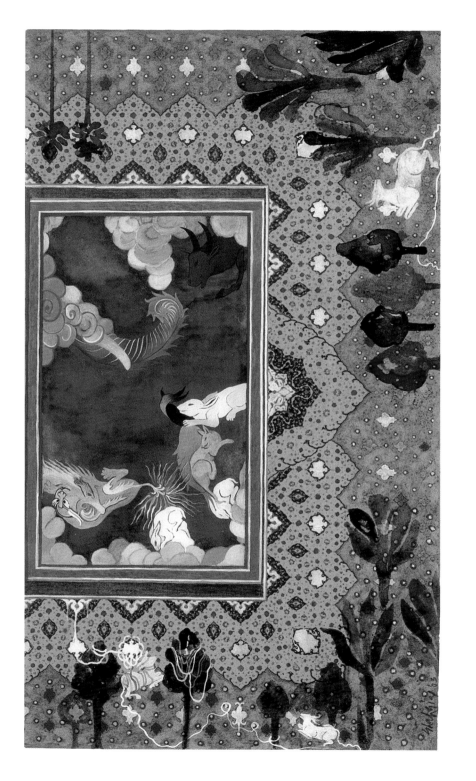

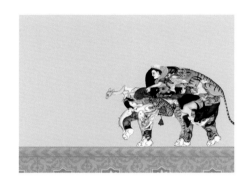

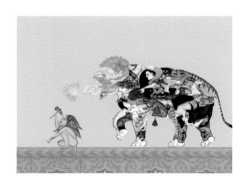

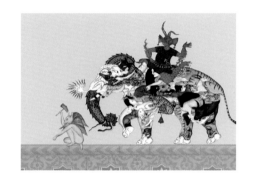

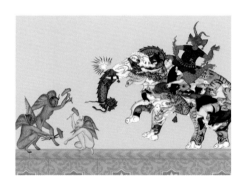

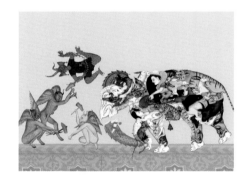

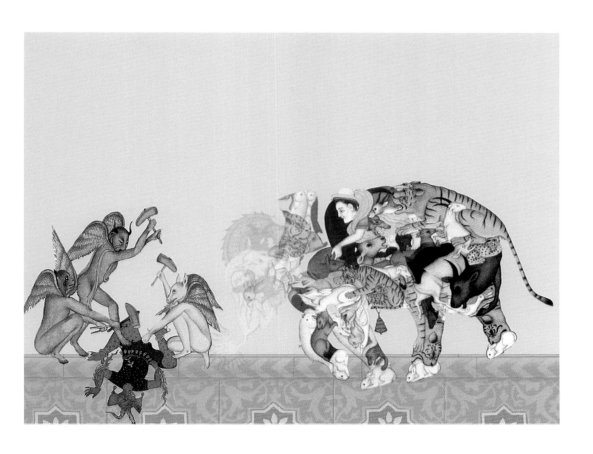

(facing page and above)
Stills from *Nemesis*, 2003
Digital animation with sound
2:02 minutes
Courtesy of the artist and
Brent Sikkema, New York

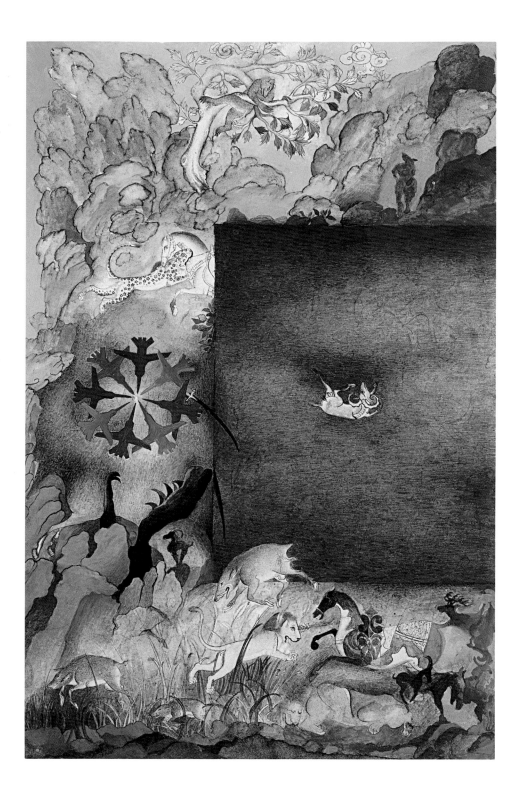

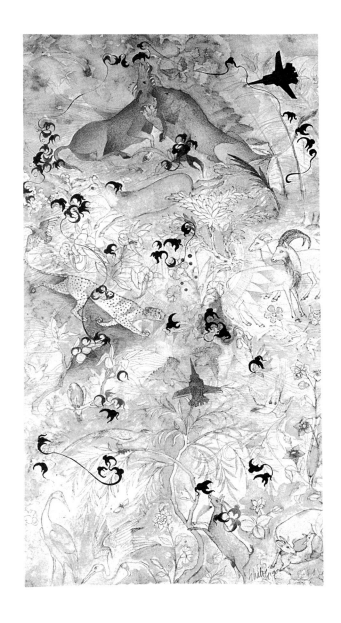

(facing page)
Usurpia, 2002
Vegetable color, dry pigment,
watercolor and tea on wasli paper
14 x 8 3/4"
Collection of Michelle Griffith

Prey, 2002
Graphite, ink, and tea on paper
11 x 6"
Collection of Michael and Jeanne Klein

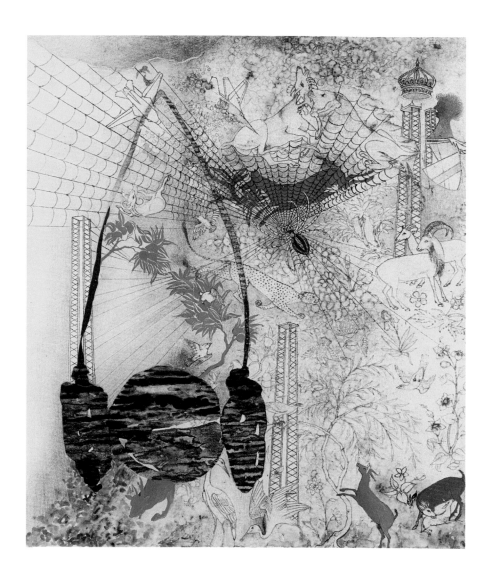

Web, 2002
Vegetable color, dry pigment,
watercolor and tea on wasli paper
9 x 7 ¹/₂"
Collection of the Museum of Art,
Rhode Island School of Design,
The Paula and Leonard Granoff Fund

(facing page)
No Fly Zone, 2002
Vegetable color, dry pigment,
watercolor, and tea on wasli paper
8 ¹/₂ x 4 ¹/₂"
Private Collection

(overleaf)
Land Escape, 2003
(one of a set of ten)
Digital photograph
9 x 12"
Collection of Barts and The London
Breast Care Centre, London

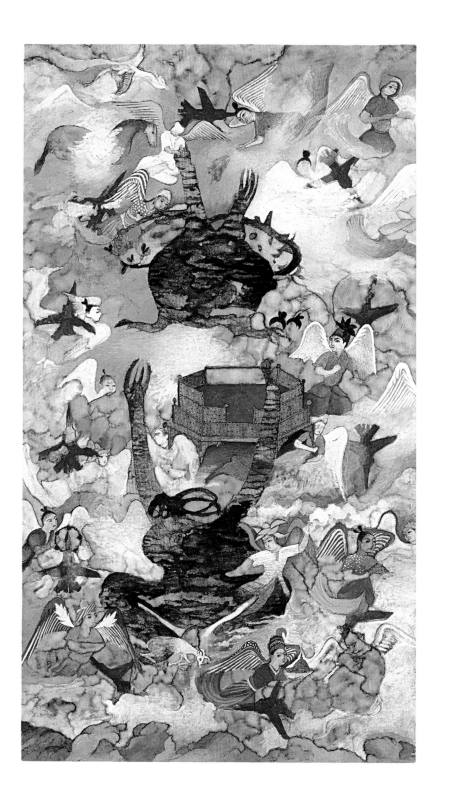

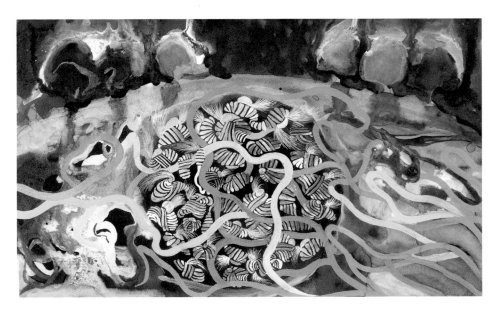

(top)
Land-Escape, Series 3, #2, 2003
Ink and gouache on prepared paper
6 x 10"
Private Collection

(bottom)
Land-Escape, Series 3, #1, 2003
Ink and gouache on prepared paper
6 x 10"
Private Collection

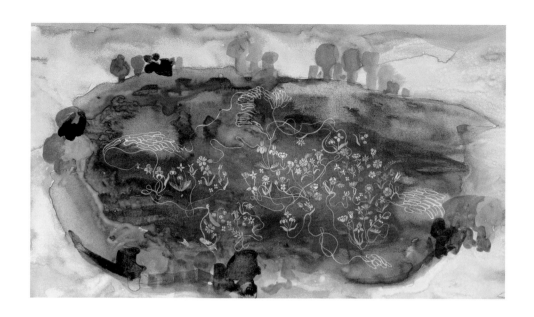

(top)
Land-Escape, Series 3, #8, 2003
Ink and gouache on prepared paper
6 x 10"
Private Collection

(bottom)
Land-Escape, Series 3, #9, 2003
Ink and gouache on prepared paper
6 x 10"
Private Collection

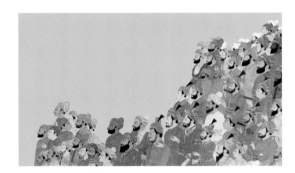

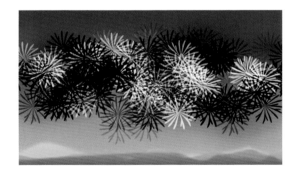

(this page and overleaf)
Stills from *Pursuit Curve*, 2004
Digital animation with sound
7:12 minutes
Courtesy of the artist and
Brent Sikkema, New York

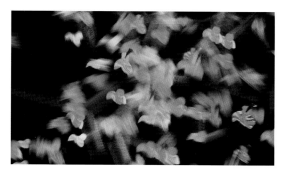

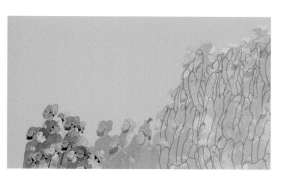

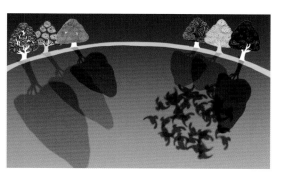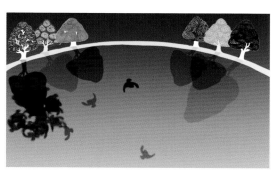

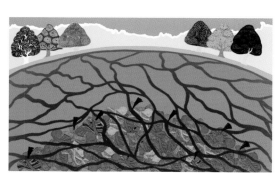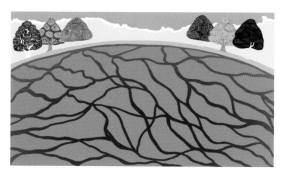

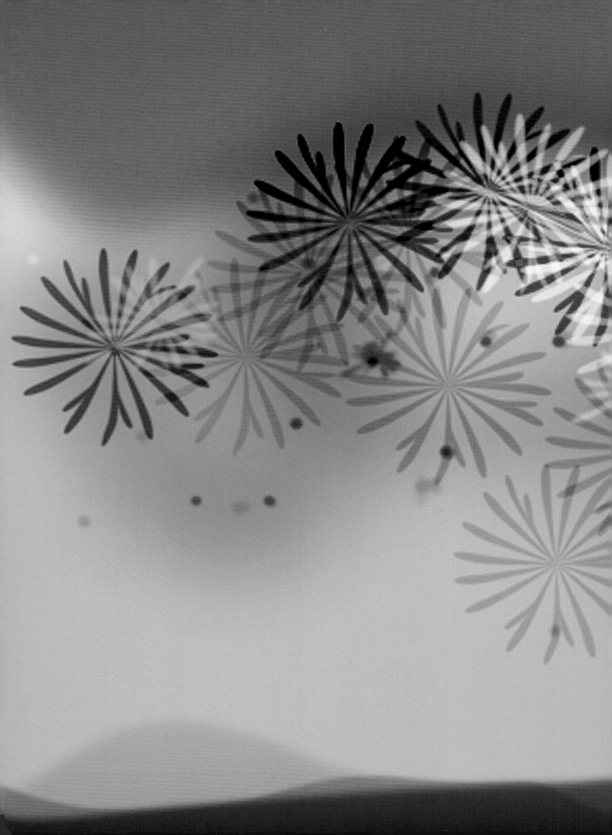

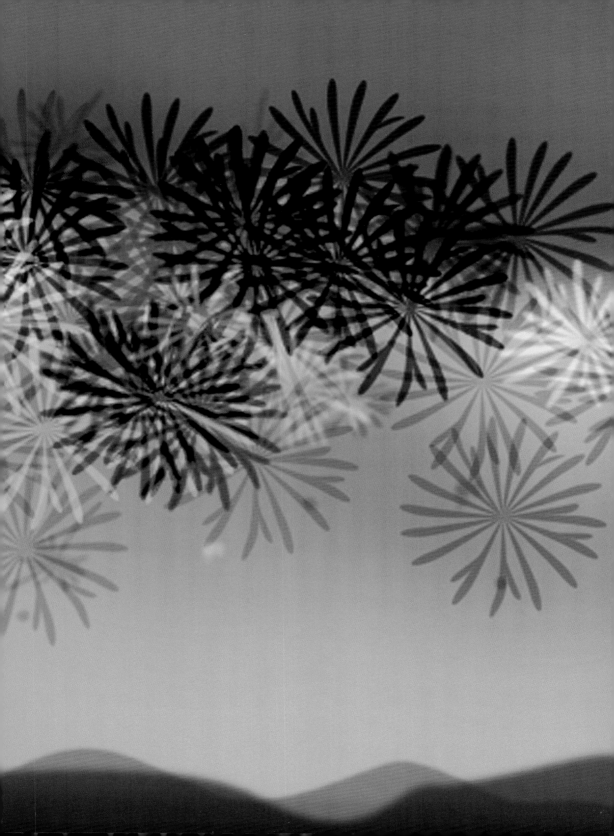

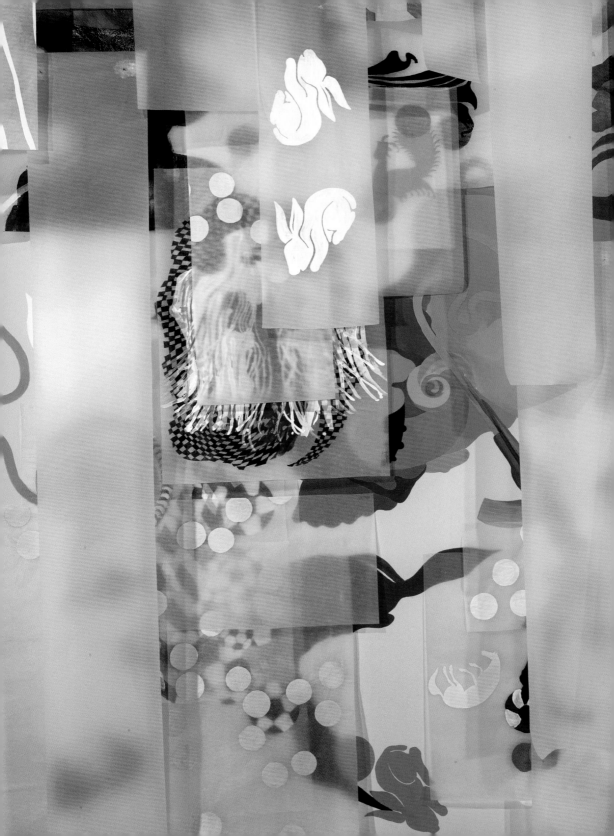

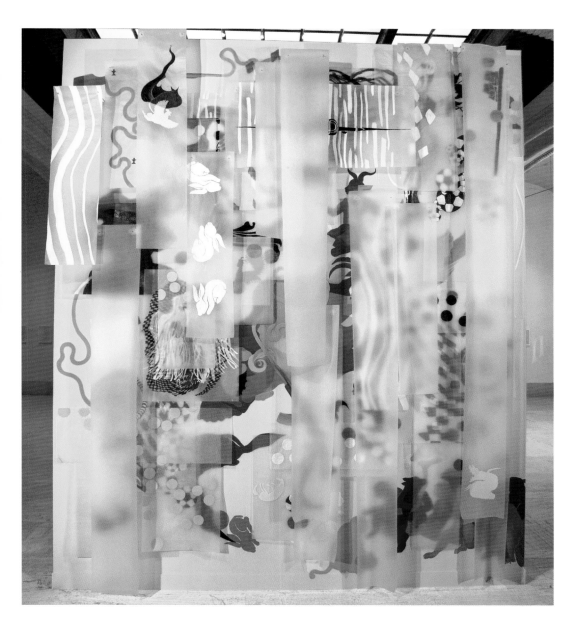

(above, detail facing)
To Reveal or Not to Reveal, 2004
Acrylic, gouache, and ink on tissue paper
Dimensions variable
Installation view, San Diego Museum of Art

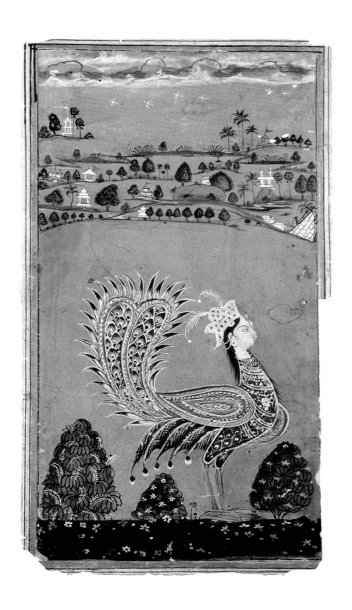

Mythical peacock with a woman's head, ca. 1750
Opaque watercolor and gold on paper
India, Andhra Pradesh, Hyderabad
8 $^{7}/_{32}$ x 4 $^{19}/_{32}$"
San Diego Museum of Art, Edwin Binney 3rd
Collection, 1990:531

(facing page)
To Desire (Flip-Flop series), 2004
Ink and gouache on paper
14 $^{3}/_{4}$ x 11 $^{1}/_{4}$"
San Diego Museum of Art,
Museum purchase, 2004:201

A Falconer Accepts Her Prey from a Page, ca. 1580
Opaque watercolor and gold on paper
India, Maharashtra, Ahmednagar
7 $^{11}/_{16}$ x 5 $^{1}/_{8}$"
San Diego Museum of Art, Edwin Binney 3rd
Collection, 1990:460

(facing page)
To Touch (Flip-Flop series), 2004
Ink and gouache on paper
15 x 12"
Collection of Nicole Fanni

*Krishna learns of Radha wilting like
a flower (Satsai of Bihari)*, 1719
Opaque watercolor and gold on paper
India, Rajasthan, Mewar
9 $^{27}/_{32}$ x 8 $^{11}/_{16}$"
San Diego Museum of Art, Edwin Binney 3rd
Collection, 1990:617

(facing page)
To Mistake (Flip-Flop series), 2004
Ink and gouache on paper
15 $^{1}/_{4}$ x 11 $^{1}/_{2}$"
San Diego Museum of Art,
Museum purchase, 2004:205

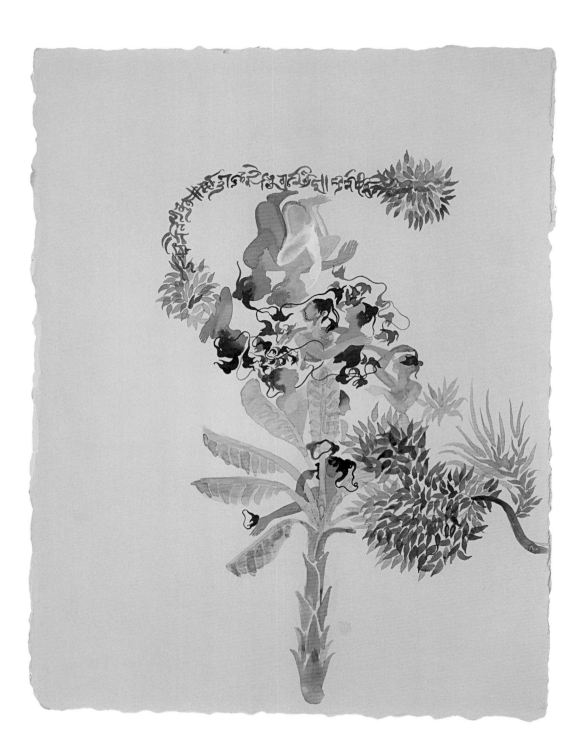

A beauty at a window with a bird, ca. 1675
Opaque watercolor and gold on paper
India, Andhra Pradesh, Golconda
10 ¹/₃₂ x 6 ⁹/₁₆"
San Diego Museum of Art, Edwin Binney 3rd
Collection, 1990:489

(facing page)
To Reflect (Flip-Flop series), 2004
Ink and gouache on paper
15 ¹/₄ x 11 ³/₈"
San Diego Museum of Art,
Museum purchase, 2004:208

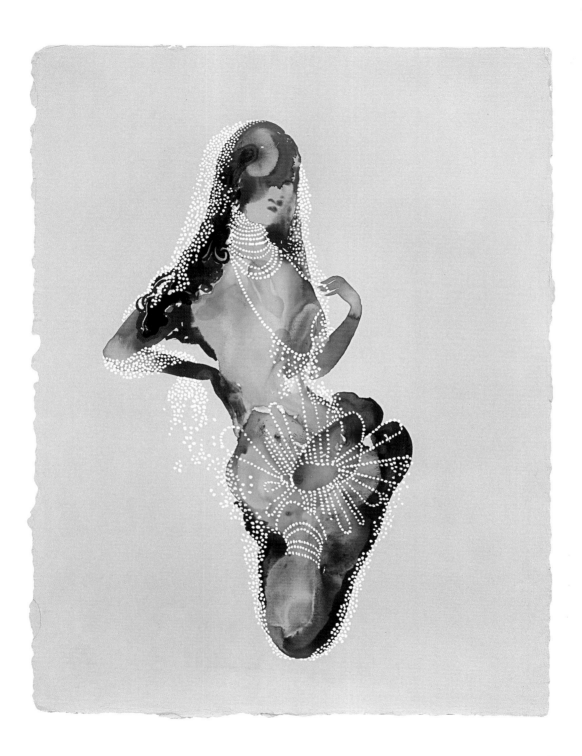

(pages 96–109)
Selections from the series
51 Ways of Looking, 2004
Ink and graphite on paper
Each sheet, 12 x 9"
Courtesy of the artist and
Brent Sikkema, New York

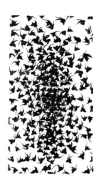

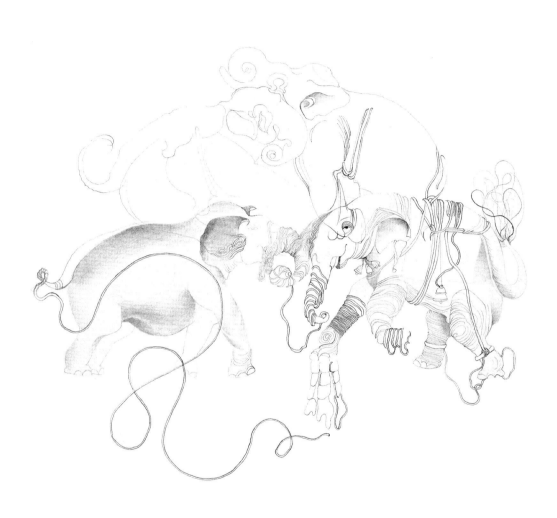

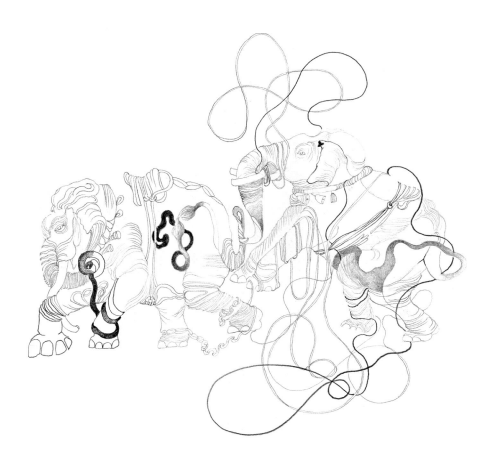

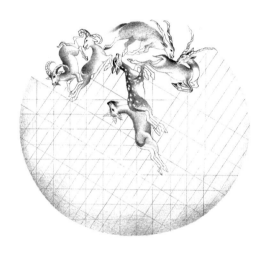

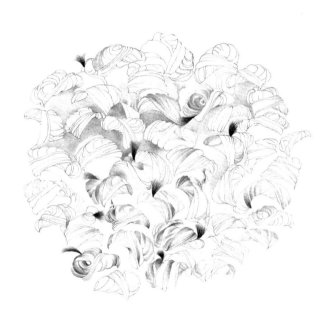

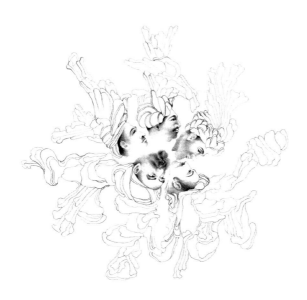

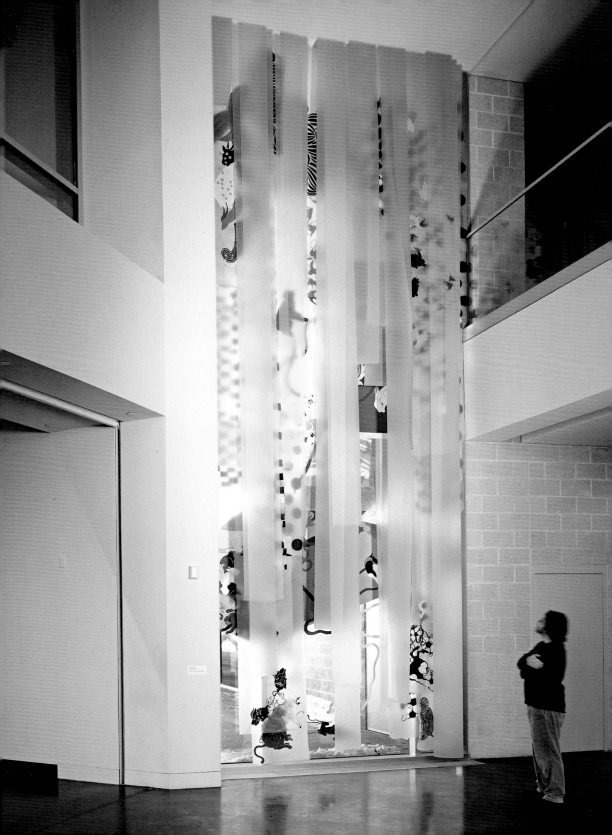

CHECKLIST

All works by Shahzia Sikander, courtesy of the artist and Brent Sikkema, New York, except where noted. All dimensions listed in inches, h x w x d

The Frances Young Tang Teaching Museum and Art Gallery, Skidmore College:

1. *SpiNN 1*, 2003
Digital animation and painting
Watercolor and dry pigment on wasli paper;
Painting: 8 x 11; animation: 6:38 minutes
Overall installation dimensions variable
Animation assistance: Anjali Gupta
Collection of Rachel and Jean-Pierre Lehmann

2. *Leap of Faith*, 2003
Gouache and digital imaging on wasli paper
12 ¹/₄ x 7
Collection of LAC–Geneva, Switzerland

3. *Nemesis*, 2003
Digital animation with sound
2:02 minutes
Sound: David Abir
Animation assistance: Chris Musgrave

4. *To Be*, 2004
Watercolor, ink, and acrylic on tissue paper and window
30 x 8 feet

5. *Flesh Flush*, 2004
Gouache, watercolor, ink, and clay on paper
Ten sheets, 15 x 11 ¹/₂ each

The Aldrich Contemporary Art Museum:

1. *51 Ways of Looking*, 2004
Graphite, ink, paint on paper
51 sheets, 12 x 9 each

2. *Pursuit Curve*, 2004
Digital animation with sound
7:12 minutes
Sound: David Abir
Animation assistance: Patrick O'Rourke

3. Shahzia Sikander and Sharmila Desai
Collaboration, 2004
Digital video with sound;
13 minutes
Choreography: Sharmila Desai
Dance floor painting: Shahzia Sikander
Video and editing: Greg Blank and Paul McGuirk
Music: DJ Cheb i Sabbah
Coordinator: Jessica Hough
Courtesy of the artists

4. *Duality*, 2004
Acrylic on wall
9 x 8 ¹/₂ feet

(facing page)
To Be, 2004
Watercolor, ink, and acrylic on tissue paper and window
30 x 8 feet
Courtesy of the artist and Brent Sikkema, New York
Installation view, Tang Museum, Skidmore College

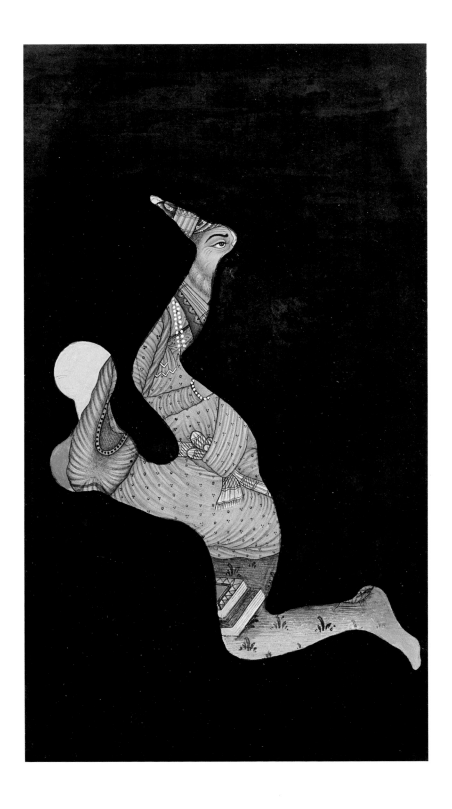

SHAHZIA SIKANDER

Born in 1969, Lahore, Pakistan
Lives and works in New York, New York

Education

1995
M.F.A., Rhode Island School of Design, Providence, Rhode Island

1992
B.F.A., National College of Arts, Lahore, Pakistan

Solo Exhibitions

2004
Shahzia Sikander: Flip Flop, San Diego Museum of Art, San Diego, California,
 March 27–June 27
Shahzia Sikander: Nemesis, The Frances Young Tang Teaching Museum and
 Art Gallery at Skidmore College, Saratoga Springs, New York, January 24–
 April 11; Traveled to The Aldrich Contemporary Art Museum, Ridgefield,
 Connecticut, September 19, 2004–January 2, 2005

2003
Drawing to Drawing, Hosfelt Gallery, San Francisco, December 13, 2003–
 January 31, 2004
SpiNN, Brent Sikkema, New York, January 11–February 8

2001
Intimacy, ArtPace, San Antonio, Texas, March 16–May 13

2000
Acts of Balance, Whitney Museum of American Art at Philip Morris (now called
 Whitney Museum of American Art at Altria), New York, April 21–July 7

1999
Directions: Shahzia Sikander, Hirshhorn Museum and Sculpture Garden,
 Smithsonian Institution, Washington, D.C., November 18, 1999–February 21,
 2000

1998
Shahzia Sikander: Drawings and Miniatures, Kemper Museum of Contemporary
 Art and Design, Kansas City, Missouri, November 13, 1998–January 10, 1999
Shahzia Sikander, The Renaissance Society at The University of Chicago,
 Chicago, March 8–April 19

(facing page)
Running on Empty 3, 2002
Watercolor and dry pigment
on paper
7 $^1/_2$ x 4 "
Private Collection

1997

Murals and Miniatures, Deitch Projects, New York, November 1–November 29

A Kind of Slight and Pleasing Dislocation, Hosfelt Gallery, San Francisco,
 April 26–May 31

1996

Shahzia Sikander, Barbara Davis Gallery, Houston, Texas, July 13–August 31

*Knock Knock, Who's There? Mithilia, Mithilia Who? (Round 5 Artist
 Installations)*, Project Row Houses, Houston, Texas, April 27–September 29

1993

Miniatures, Embassy of Pakistan, Washington D.C.

Group Exhibitions

2004

*La Alegría de mis Sueños (The Joy of My Dreams): the First International
 Biennial of Contemporary Art*, Seville, Spain, October 3–December 5

Along the X-Axis: Video Art from India and Pakistan, Apeejay Media Gallery,
 New Delhi, India, March–April

Watercolor Worlds, Dorsky Gallery, New York, February 8–April 5

Beyond East and West: Seven Transnational Artists, Krannert Art Museum,
 University of Illinois at Urbana-Champaign, Champaign, Illinois,
 January 23–April 4; Traveled to Louisiana State University Museum of Art,
 Baton Rouge, Louisiana, April 16–September 4; Hood Museum of Art,
 Dartmouth College, Hanover, New Hampshire, October 9–December 12;
 Williams College Museum of Art, Williamstown, Massachusetts,
 February 19, 2005–May 15, 2005

2003

Eighth International Istanbul Biennial, Istanbul, Turkey, September 19–
 November 16

Aliens in America: Others in the USA, Lamont Gallery, Phillips Exeter Academy,
 Exeter, New Hampshire, September 13–October 22

For the Record: Drawing Contemporary Life, Vancouver Art Gallery, Vancouver,
 British Columbia, June 28–September 28

2002

AOP 2002: The 37th Art on Paper Exhibition, Weatherspoon Art Museum,
 Greensboro, North Carolina, November 17, 2002–January 19, 2003

Drawing Now: Eight Propositions, The Museum of Modern Art, Queens,
 New York, October 17, 2002–January 6, 2003

Time/Frame, Jack S. Blanton Museum of Art, University of Texas at Austin,
 Austin, Texas, January 25–July 28

Urgent Painting, Musée d'Art moderne de la Ville de Paris/ARC, Paris,
 January 17–March 3

2001

Conversations with Traditions: Nilima Sheikh and Shahzia Sikander,
 The Asia Society, New York, November 17, 2001–February 17, 2002;
 Traveled to Middlebury College Museum of Art, Middlebury, Vermont,
 September 12, 2002–December 1, 2002; Seattle Art Museum, Seattle,
 June 12, 2003–September 7, 2003
ARS 01, Kiasma, Museum of Contemporary Art, Helsinki, September 30,
 2001–January 20, 2002
Threads of Vision: Toward a New Feminine Poetics, Cleveland Center for
 Contemporary Art, Cleveland, Ohio, September 14–November 25
Expanding Tradition: Contemporary Works Influenced by Indian Miniatures,
 Deutsche Bank Lobby Gallery, New York, April 3–May 18
New Works: 01.1 Rivane Neuenschwander, Shahzia Sikander, Tony Villejo,
 ArtPace, San Antonio, Texas, March 16–May13
Elusive Paradise: The Millennium Prize, National Gallery of Canada, Ottawa,
 February 9–May 13.
New Artists, Recent Works, Rhotas Gallery, Islamabad, Pakistan

2000

Projects 70, The Museum of Modern Art, New York, November 22, 2000–
 March 13, 2001
00, Barbara Gladstone Gallery, New York, June 1–September 27
*Drawing on the Figure: Works on paper of the 1990s from the Manilow
 Collection,* Museum of Contemporary Art, Chicago, March 18–June 25
Greater New York, P.S.1 Contemporary Art Center, Queens, New York,
 February 27–May 16

1999

Art-Worlds in Dialogue, Museum Ludwig, Cologne, Germany, November 5,
 1999–March 19, 2000

*Is It Me, or Is It You, or
Is It Our, Racial Veils,* 1997
Acrylic on wall
6 $^{1}/_{2}$ x 9 feet overall
Installation view, *Selections,*
The Drawing Center, New
York,1997

The American Century: Art & Culture 1900–2000, Part II, 1950–2000, Whitney
 Museum of American Art, New York, September 26, 1999–February 13, 2000
Beyond the Future: The Third Asia-Pacific Triennial of Contemporary Art,
 Queensland Art Gallery, Brisbane, Australia, September 9, 1999–January 26,
 2000
Negotiating Small Truths, Jack S. Blanton Museum of Art, University of Texas
 at Austin, Austin, Texas, September 2–October 24

1998

Cinco continentes y una ciudad: Salón internacional de pintura, Museo de la
 Ciudad de México, Mexico City, November 26, 1998–February 28, 1999
I Love New York, Museum Ludwig, Cologne, Germany, November 6,
 1998–January 31, 1999
On the Wall, Forum for Contemporary Art (now called Contemporary Art
 Museum St. Louis), St. Louis, Missouri, August 28–October 31
Pop Surrealism, The Aldrich Contemporary Art Museum, Ridgefield,
 Connecticut, June 7–August 30
Liberating Tradition: Byron Kim, Yinka Shonibare and Shahzia Sikander,
 Center for Curatorial Studies, Bard College, Annandale-On-Hudson,
 New York, May 10–May 24
Global Vision: New Art from the 90s, Part II, Deste Foundation, Center
 for Contemporary Art, Athens, May 7, 1998–January 30, 1999
Hedge: Between Time and Intent. Thomas Healy, New York

1997

Out of India: Contemporary Art of the South Asian Diaspora, Queens Museum
 of Art, Flushing, New York. November 21, 1997–March 22, 1998
Three Great Walls, Yerba Buena Center for the Arts, San Francisco,
 September 20–November 30
Project Painting, Lehman Maupin Gallery, New York, September 10–October 11
1997 Biennial Exhibition, Whitney Museum of American Art, New York,
 March 20–June 15
Eastern Edge, Laing Gallery, Newcastle, England, March 8–June 8
Core 1997 Exhibition, Glassell School of Art, Houston, Texas, March 7–April 13
Selections Spring '97, The Drawing Center, New York, February 20–March 29
Biennial International for Sculpture and Drawing, Caldas da Rainha, Portugal

1996

Packaged Paradise, 2003
Acrylic on wall
Dimensions variable
Installation view, *Platform*,
Garanati Contemporary Art
Center, Istanbul *Biennial*, 2003

An Intelligent Rebellion, Women Artists of Pakistan, Cartwright Hall, Lister Park,
 Bradford, England; traveled to Rotherham Art Gallery, Rotherham, England,
 September 8–October 21
New Works, Michael Gold Gallery, New York, September
1996 Core Exhibition, Glassell School of Art, Museum of Fine Arts, Houston,
 Texas, March 29–April 28

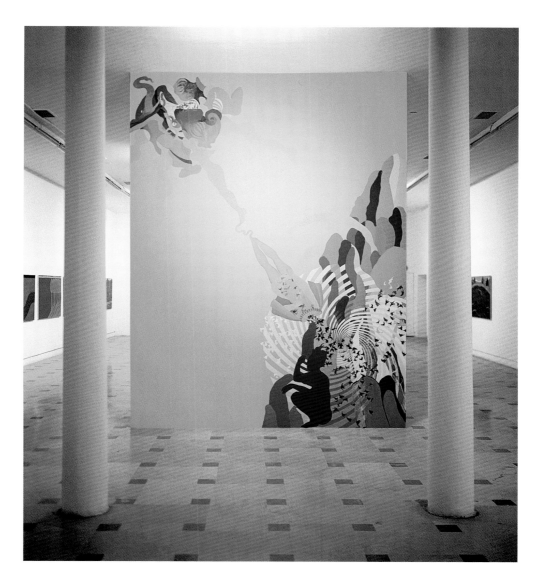

1996 Houston Area Exhibition, Blaffer Gallery, University of Houston, Texas,
February 3–March 31
Interplay: Celebrating the Poetry of Pablo Neruda, Slover McCutcheon Gallery,
Houston, Texas, May–July 6

1994

A Selection of Contemporary Paintings from Pakistan, Pacific Asia Museum,
Pasadena, California, February 9–July 17

Books and Catalogues

Antelo-Suarez, Sandra, et al. *Urgent Painting.* Exhibition catalogue. Paris: ARC,
 Musée d'Art moderne de la Ville de Paris, 2002.

Boris, Staci. *Drawing on the Figure: Works on paper of the 1990s from
 the Manilow Collection.* Exhibition catalogue. Chicago: Museum of
 Contemporary Art, 2000.

Cameron, Dan. *Poetic Justice: the Eighth International Istanbul Biennial.*
 Exhibition catalogue. Istanbul: Istanbul Foundation for Culture and Arts,
 2003.

Carlozzi, Annette DiMeo. *Negotiating Small Truths.* Exhibition catalogue.
 Austin, Texas: Jack S. Blanton Museum of Art, 1999.

Chambers, Kristin. *Threads of Vision: Toward a New Feminine Poetics.*
 Exhibition catalogue. Cleveland: Cleveland Center for Contemporary Art,
 2001. Interview by Roxana Marcoci.

Colpit, Frances. *Core Fellows Exhibition 1997.* Exhibition catalogue. Houston,
 Texas: Glassell School of Art, Museum of Fine Arts, 1997.

Contemporary Art Commissions at the Asia Society and Museum. Exhibition
 catalogue. New York: Asia Society, 2002.

Daftari, Fereshteh. *ARS 01.* Exhibition catalogue. Helsinki: Kiasma, Museum
 of Contemporary Art, 2001.

—. *Projects 70: Janine Antoni, Shahzia Sikander, Kara Walker.* Exhibition
 brochure. New York: Museum of Modern Art, 2000.

Desai, Vishakha N. *Conversations with Traditions: Nilima Sheikh and
 Shahzia Sikander.* Exhibition catalogue. New York: Asia Society, 2001.

Farris, Phoebe, ed. *Women Artists of Color: A Bio-Critical Sourcebook to
 20th Century Artists in the Americas.* Westport, Connecticut: Greenwood
 Press, 1999.

Farver, Jane. *Out of India: Contemporary Art of the South Asian Diaspora.*
 Exhibition catalogue. New York: Queens Museum of Art, 1997.

Fletcher, Valerie. *Shahzia Sikander.* Exhibition brochure. Washington DC:
 Hirshhorn Museum and Sculpture Garden, 1999.

Fletcher, Valerie, and Mark Sheps, et al. eds. *Kunstweltem im Dialog.* Exhibition
 catalogue. Cologne: Museum Ludwig, 1999. In German.

Friis-Hansen, Dana. *Beyond the Future: the Third Asia-Pacific Triennial.*
 Exhibition catalogue. Brisbane, Australia: Queensland Art Gallery, 1999.

Gaonkar, Dilip Parameshwar, ed. *Alternative Modernities.* Durham, North
 Carolina: Duke University Press, 2001. Essay by Kipesh Chakrabarty.

Gregos, Katerina. *Global Vision: New Art from the 90s, Part II.* Exhibition
 brochure. Athens: Deste Foundation, Center for Contemporary Art, 1999.

Hashmi, Salima, and Niva Poovaya-Smith. *An Intelligent Rebellion: Women
 Artists of Pakistan.* Exhibition catalogue. Bradford, England: City of Bradford
 Metropolitan Council, 1996.

Heller, Nancy G. *Women Artists.* New York: Abbeville Press, 2003.

Hertz, Betti-Sue. *Shahzia Sikander: Flip Flop.* Exhibition brochure. San Diego: San Diego Museum of Art, 2004.

Hoptman, Laura. *Drawing Now: Eight Propositions.* Exhibition catalogue. New York: The Museum of Modern Art, 2002.

Hough, Jessica. *Liberating Tradition: Byron Kim, Yinka Shonibare and Shahzia Sikander, May 10–24, 1998.* Exhibition brochure. Annandale-on-Hudson, New York: Center for Curatorial Studies, Bard College, 1998.

Iarrapino, Elizabeth. *Shahzia Sikander: Murals and Miniatures, November 1–29, 1997.* Exhibition brochure. New York: Dietch Projects, 1997.

Jenny, Barbara Rita. *Aliens in America: Others in the USA.* Exhibition brochure. Exeter, New Hampshire: Lamont Gallery, Phillips Exeter Academy, 2003. Essay by Chris Thompson.

Kim, Elaine H., Margo Machida and Sharon Mizoto. *Fresh Talk, Daring Gazes: Coversations on Asian American Art.* Berkeley, California: University of California Press, 2003.

Marquardt, Janet, and Stephen Eskilson. *Frames of Reference: Art History and the World.* New York: McGraw-Hill, 2005.

Nemiroff, Diana, and Johanne Sloan. *Elusive Paradise: the Millennium Prize.* Exhibition catalogue. Ottawa: National Gallery of Canada, 2001.

O'Brian, David, and David Prochaska. *Beyond East and West: Seven Transnational Artists.* Exhibition catalogue. Champaign, Illinois: Krannert Museum of Art, 2004.

Pagel, David. *Core Fellows Exhibition 1996.* Exhibition catalogue. Houston, Texas: Glassell School of Art, Museum of Fine Arts, 1996.

Palau, Marta, et al. *Cinco continentes y una ciudad.* Exhibition catalogue. Mexico City: Museo de la Ciudad de México, 1998. Essay by Yu Yeon Kim.

Phillips, Lisa. *The American Century: Art and Culture, 1950–2000.* Exhibition catalogue. New York: Whitney Museum of American Art, 1999.

Phillips, Lisa, and Louise Neri. *1997 Biennial.* Exhibition catalogue. New York: Whitney Museum of American Art, 1997.

Untitled, 1998
Acrylic, gouache, and ink
on tissue paper on wall
11 x 20 feet
Installation view,
The Renaissance Society,
Chicago, Illinois, 1998

Reckit, Helena, and Peggy Phelan. *Art and Feminism*. London and New York: Phaidon, 2001.

Schaffner, Ingrid. *Project Painting*. Exhibition catalogue. New York: Lehman Maupin Gallery, 1997.

Self, Dana. *Shahzia Sikander: Drawings and Miniatures*. Exhibition brochure. Kansas City, Missouri: Kemper Museum of Contemporary Art, 1998.

Shahzia Sikander. Exhibition catalogue. Chicago: University of Chicago Press in collaboration with The Renaissance Society, 1999. Essay by Faisal Devji; interview by Homi Bhabha.

Singer, Debra. *Shahzia Sikander: Acts of Balance*. Exhibition brochure. New York: Whitney Museum of American Art at Philip Morris, 2000.

Sirhandi, Marcella. *A Selection of Contemporary Paintings from Pakistan*. Exhibition catalogue. Pasadena, California: Pacific Asia Museum, 1994.

Sollins, Susan, et al. *Art: 21, Art in the 21st Century*. New York: Harry N. Abrams, 2001. Essay by Lynn M. Herbert.

Szeemann, Harald. *La Alegría de mis Sueños (The Joy of My Dreams): the First International Biennial of Contemporary Art*. Exhibition catalogue. Seville: BIACS Foundation, 2004.

Watkin, Mel. *On the Wall: Selections from The Drawing Center*. Exhibition catalogue. St. Louis: Forum for Contemporary Art, 1998.

Periodicals and Texts

Ahmady, Leeza. "Shahzia Sikander: Aldrich Contemporary Art Museum." *Flash Art*, no. 239 (November/December 2004).

Atamian, Christopher. "Review-Project Painting." *Review* (1 October 1997): 119–20.

Auricchio, Laura. "Shahzia Sikander: SpiNN." *TimeOut New York* (23 January 2003).

Baker, Kenneth. "Sikander and O'Reilly Showing at Hosfelt Gallery." *San Francisco Chronicle* (10 January 2004): D12.

—. "Uprooted." *San Francisco Chronicle* (22 May 1997).

Bell, Clare. "Shahzia Sikander: Murals and Miniatures." *Art On Paper* (March/April 1998): 53.

Bhabha, Homi. "Miniaturizing Modernity." *Public Culture* 2, no. 1 (Winter 1999).

Bonetti, David. "Yerba Buena Center Chalks Up More Winners." *The San Francisco Examiner* (26 September 1997).

Bush, Julie. "Directions: Shahzia Sikander, Hirshhorn Museum and Sculpture Garden." *Art On Paper* (May/June 2000).

Camhi, Leslie. "Xtra Small." *The Village Voice* 42, no. 47 (25 November 1997): 107.

Carrier, David. "Shahzia Sikander: Aldrich Contemporary Art Museum." *Artforum* 43, no. 5 (January 2005).

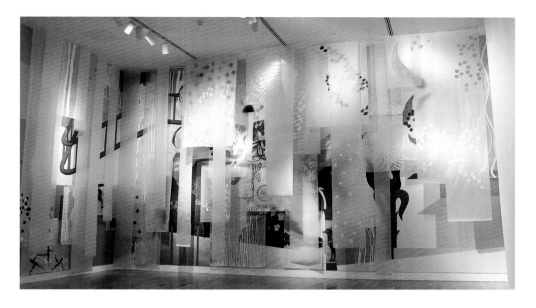

Cotter, Holland. "Cosmopolitan Trove, On the Road to China." *The New York Times* (16 November 2001): E29.

—. "Many Shows and Many Indias." *The New York Times* (26 December 1997).

—. "Shahzia Sikander, Acts of Balance." *The New York Times* (9 June 2000).

Daftari, Fereshteh. "Beyond Islamic Roots: Beyond Modernism." *RES* 43 (Spring 2003).

Farr, Sheila. "Shades of the Divine." *The Seattle Times* (12 June 2003).

Friis-Hansen, Dana. "Full Blown." *Art Asia Pacific* 16, (1997): 44–49.

Gomez, Edward. "Between Past and Present." *Art on Paper* 8, no. 1 (September/October 2003): 48–51.

—. "Past is Present." *Art and Antiques* 21, no. 11 (December 1998): 60–66.

Gomez-Haro, Germaine. "Five Continents and a City: Museo de la Ciudad de México."

Art Nexus 33 (August–October 1999): 123–26.

Goodman, Jonathan. "Shahzia Sikander." *Art Asia Pacific* 29 (2001): 96.

—. "Small Pleasures." *World Art* 15 (1997): 28–31.

Greenberg, Kevin. "Sikander Presents Veiled Illusions." *Chicago Maroon* 109, no. 38 (7 April 1998): 1.

Gupta, Somini. "Joining Hindu and Muslim Icons in Art." *The New York Times* (26 December 2001).

Hashmi, Salima. "Shahzia's Miniatures." *Libas International* (March 1992).

Heartney, Eleanor. "Nilima Sheikh and Shahzia Sikander at the Asia Society." *Art in America* (March 2002): 133–34.

Henry, Max. "Shahzia Sikander." *Art Newspaper* 11, no.105 (July/August 2000): 77.

Hoban, Phoebe. "The Mod Squad." *New York Magazine* (11 January 1999): 30–37.

Hung, Melissa. "The Space Between." *Hyphen Magazine* 1 (Summer 2003): 8–9.

Chaman (2), 2001
Acrylic, gouache, and ink
on tissue paper on wall
Dimensions variable
Installation view, *Elusive
Paradise*, National Gallery
of Canada, Ottawa, 2001

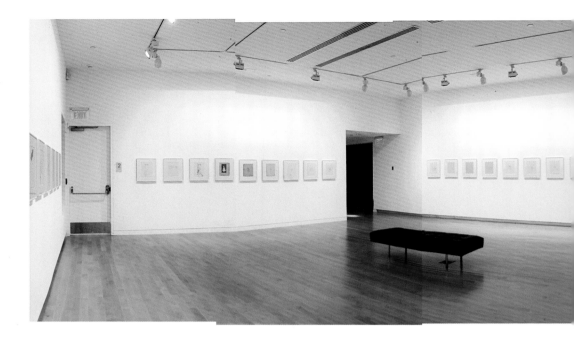

Hunt, David. "First A Disclosure (Or at Least a Helpful Caveat)." *Bomb* (Summer 2001).

Jana, Reena. "Cultural Weaving." *Asian Art News* (March/April 1997).

—. "Shahzia Sikander: Celebration of Femaleness." *Flash Art* (March/April 1998).

Johnston, Patricia. "Studio- Shahzia Sikander: Reinventing the Miniature." *ARTnews* 97, no. 2 (February 1998): 86–88.

Kimmelman, Michael. "Narratives Snagged on the Cutting Edge." *The New York Times* (21 March 1997).

Kley, Elisabeth. "Shahzia Sikander." *ARTnews* 102, no. 4 (April 2003): 123–24.

Kunitz, Daniel. "Shahzia Sikander: Miniatures." *The Paris Review* 195, (Spring 2003): 121–28.

Lutfy, Carol. "Asian Artists In America: Shahzia Sikander." *Atelier International* 832, (December 1996): 49–57.

MacAdam, Barbara A. "Whitney Biennial." *ARTnews* 96, no. 5 (May 1997): 163.

McEvilley, Thomas. "Tracking the Indian Diaspora." *Art in America* 86, no. 10 (October 1998): 74+.

Murdock, Robert. "Review-Murals and Miniatures." *Review* (15 November 1997): 19–20.

Pedersen, Victoria. "Echoes from the Orient." *Paper* (May 2000).

"Pencil Pushers." *Art on Paper* 7, no. 5 (March 2003): 94.

Pollack, Barbara. "The New Look of Feminism." *ARTnews* 100, no. 8 (September 2001): 132–36.

Saltz, Jerry. "Good on Paper." *The Village Voice* (30 October 2002): 57.

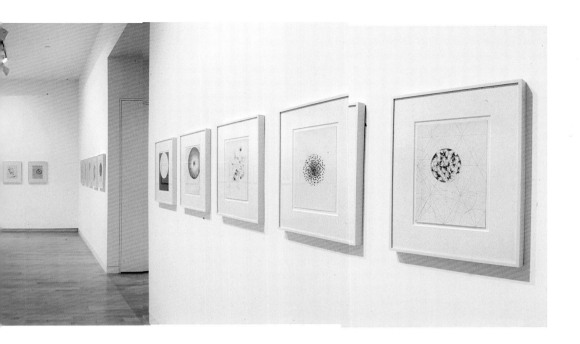

—. "Murals and Miniatures." *TimeOut New York*, no. 114 (27 November 1997): 52.

Sand, J. Olivia. Interview. *Asian Art* (January 2002).

Schjeldahl, Peter. "Painting Rules." *The Village Voice* 42, no. 39 (30 September 1997): 97.

Schwabsky, Barry. "A Painter of Miniatures on a Maximum Scale." *The New York Times* (14 May 2000): E41.

—. "Shahzia Sikander, Out of India." *Artforum* 36, no. 8 (April 1998): 113.

Sirmans, Franklin. "Group Shows-Selections Spring '97, The Drawing Center." *Flash Art* (May/June 1997).

—. "Shahzia Sikander, Acts of Balance." *TimeOut* (15 June 2000).

Smith, Roberta. "Drawing that Pushes Beyond the Boundaries." *The New York Times*, (21 March 1997).

—. "Retreat From the Wild Shores of Abstraction." *The New York Times* (18 October 2002): E31.

Wakefield, Neville. "Three to Watch." *Elle Décor*, no. 56 (December/January 1997): 62–70.

Ward, Melanie. "Master Class." *Harper's Bazaar* (December 2000): 224.

Wehr, Anne. "Asia Society Returns Home With Nilima Sheikh and Shahzia Sikander's Miniature Paintings." *TimeOut* 326 (December 2001).

Young, Lisa Laye. "Shahzia Sikander at Brent Sikkema." *Tema Celeste* 97 (May–June 2003): 79.

Zinnes, Harriet. "Projects 70," *NY Arts* (January 2001).

—. Review. *NY Arts* (May 2000): 73.

(above)
51 Ways Of Looking, 2004
Installation view, *Nemesis*,
The Adrich Contemporary
Art Museum, 2004

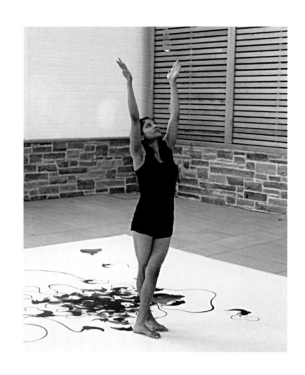

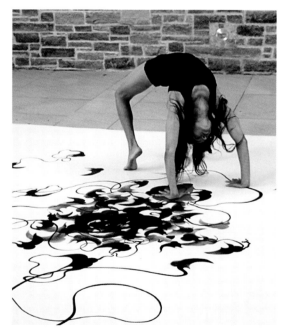

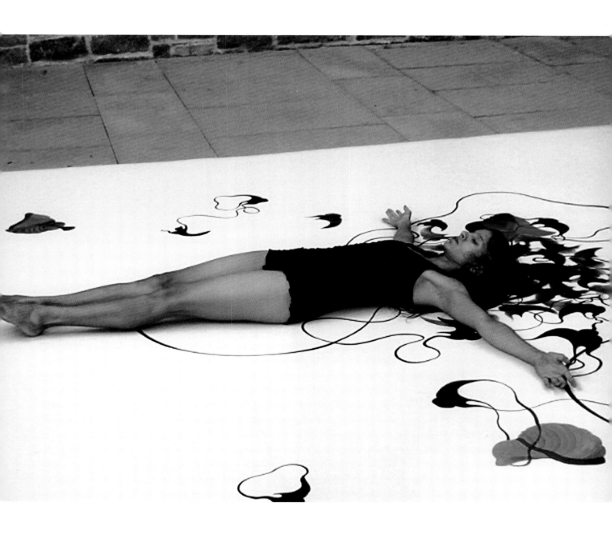

Shahzia Sikander and Sharmila Desai
Collaboration, 2004
Performance views, The Aldrich Contemporary
Art Museum, 2004

ACKNOWLEDGMENTS

This exhibition marks the first collaboration between The Aldrich Contemporary Art Museum and The Tang Teaching Museum and Art Gallery at Skidmore College. We have shared experiences with several artists who have exhibited at both of our institutions and we look forward to even more collaboration in the future. Shahzia Sikander's exhibition *Nemesis* not only allowed us an opportunity to look back on ten years of her important work but to also engage in one of the most exciting components of our job—to help an artist realize new works and explore new ideas. Our work together on this exhibition and catalogue was a rich and rewarding experience and we have many people to thank.

Nemesis is the sixth in the *Opener* series at The Tang, which is generously supported by The Laurie Tisch Sussman Foundation, The New York State Council on the Arts, the Overbrook Foundation, and the Friends of The Tang. We are especially grateful for the support that a grant from the Islamic World Arts Initiative provided for this exhibition. This initiative of Arts International, funded by the Doris Duke Foundation for Islamic Art, allowed Shahzia to produce *Pursuit Curve*, and supported new site-specific projects and an innovative collaboration with dancer Sharmila Desai. Thanks to Kay Takeda at Arts International.

At Brent Sikkema, New York, we are grateful to Brent Sikkema, Michael Jenkins, Ellie Bronson, and especially Meg Malloy. They were in nearly constant contact with us during every stage of the project, and their cheerfulness and genuine enthusiasm for Shahzia's work is much appreciated.

At The Aldrich, thanks to Jane Calverley, Lousana Campagna, Nina Carlson, Kristina Critchlow, Lynn Durkin, Larry Eishen, Rachel Foglia, Amy Grabowski, Mary Kenealy, Richard Klein, Steven Needham, Carolina Pedraza, Robin Phillips, Maureen Shanahan, Andrea Silver, Liz Spears, Barbara Toplin, Aran Winterbottom, and Barbara Zohar. As always the installation crew did a superb job, especially Chris Durante and Jim Hett. Special thanks to Director, Harry Philbrick for supporting our collaboration from the start.

At The Tang Museum, thanks to installation crew members Sam Coe, Abraham Ferraro, Torrance Fish, Chris Oliver, Alex Roediger, and Joe

Yetto. Thanks also to Tang staff Helaina Blume, Ginger Ertz, Lori Geraghty, Elizabeth Karp, Susi Kerr, Gayle King, Chris Kobuskie, Ginny Kollak, Barbara Schrade, and Gretchen Wagner. Also thanks to Barbara Melville, Mary Jo Driscoll, and Barry Pritzker for their support. Special thanks to Skidmore visiting professor, Deborah Hutton, who is now Assistant Professor of Asian and Islamic art history at The College of New Jersey, for her teaching with the exhibition at Skidmore, her public talk with Shahzia, and for her assistance with the essay for the catalogue.

The exhibition included several new works that relied on a team of individuals that advised us and worked long hours with Shahzia. Thanks to Christi Byrd and Karina Ryan from the artist's studio for their expert installation assistance. We are very grateful to Patrick O'Rourke at The Tang Museum who worked closely with the artist in her studio and at the museum to carefully craft new animations, and to David Abir who not only produced outstanding sound components for her animations, but also spent many hours installing *Pursuit Curve* in The Aldrich's sound gallery. Thanks to Greg Blank and Paul McGuirk who filmed the performance piece with Sharmila Desai at The Aldrich and edited it into a remarkable work in its own right.

Lastly, we would like to thank Sharmila Desai for her generous spirit of collaboration. She choreographed a new dance piece to accompany the exhibition that was performed at each opening to the breathless awe and joy of our audiences. And to Shahzia, we extend our greatest admiration and heartfelt thanks for her hours of work to create new site-specific installations at both our museums, for her ambition, which pushed us to consider an exhilarating new body of work, and her ideas that consistently move us to reconsider what we think we know about the world and each other. It is our great pleasure to spend time with you and your work. You can count us as lifelong fans.

IAN BERRY and JESSICA HOUGH, Curators

This catalogue accompanies the exhibition

OPENER **6**

SHAHZIA SIKANDER: NEMESIS

The Tang Teaching Museum and Art Gallery at Skidmore College
Saratoga Springs, New York
January 24–April 11, 2004

The Aldrich Contemporary Art Museum
Ridgefield, Connecticut
September 19, 2004–January 5, 2005

The Tang Teaching Museum and Art Gallery
Skidmore College
815 North Broadway
Saratoga Springs, New York 12866
T 518 580 8080
F 518 580 5069
www.skidmore.edu/tang

NYSCA

artsinternational

DORIS DUKE
FOUNDATION FOR ISLAMIC ART

This exhibition and publication are made possible in part with public funds from the New York State Council on the Arts, a state agency, The Laurie Tisch Sussman Foundation, The Overbrook Foundation, and the Friends of the Tang. At The Aldrich Museum, funding was provided by: Altria Group, Inc., COACH, Connecticut Commission on Culture & Tourism, Erco Lighting, Inc., Anne S. Richardson Fund, Ridgefield Bank, and UST. The catalogue is also supported by Brent Sikkema, New York.

The works of art in this exhibition were made possible, in large part, by the Islamic World Arts Initiative, a program of Arts International generously supported by the Doris Duke Foundation for Islamic Art.

ISBN 0-9725188-4-3

Library of Congress control number: 2004111757

Cover:
Plush Blush series, 2003
Ink and gouache on paper
15 x 12"
Collection of Scott Olivet,
Portland, Oregon

Designed by Bethany Johns
Printed in Germany by Cantz

Photographs:
Page 1: Photograph by Shahzia Sikander
Page 25: Geoffrey Clements
Page 40, 42: Lee Stalsworth
Page 41: D. James Dee
Page 44, 45: George Hirose
Pages 56, 69, 70, 75, 76, 89, 91, 93, 95, 115: Erma Estwick
Pages 122–123: Steven Needham
Pages 124–125: Jessica Hough